IMAGES
of America

NORTH ADAMS

IMAGES
of America

NORTH ADAMS

Robert Campanile

ARCADIA

First printed in 2001.

Published by Arcadia Publishing,
an imprint of Tempus Publishing, Inc.
2A Cumberland Street
Charleston, SC 29401

Printed in Great Britain.

Library of Congress Catalog Card Number: Applied for.

For all general information contact Arcadia Publishing at:
Telephone 843-853-2070
Fax 843-853-0044
E-Mail sales@arcadiapublishing.com

For customer service and orders:
Toll-Free 1-888-313-2665

Visit us on the internet at http://www.arcadiapublishing.com

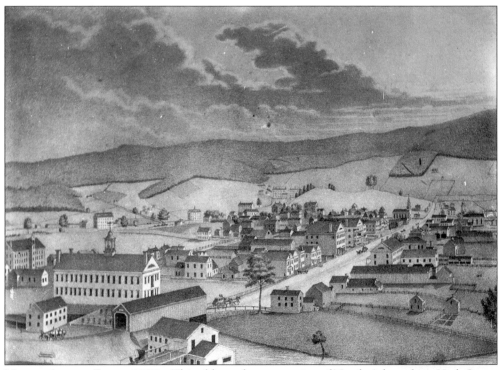

NORTH ADAMS, EARLY 1800S. This old woodcut engraving of North Adams from High Street shows the covered bridge that is now at the bottom of Main Street.

CONTENTS

ACKNOWLEDGMENTS

It was my privilege to have worked with the following people and organizations that supported this book project. I thank my editor, Megan Dumm, and Arcadia Publishing for the opportunity to take part in the historic preservation that projects like this help support. The success of the book would be impossible without the North Adams Historical Society and Museum of History and Science. Most of the images are from the society's collections and from individual members who loaned us their personal collections. It is impossible to list all the photographers who, through the decades, have recorded the images and the numerous people who eventually donated them to the society and museum. Their efforts in preserving the city's history are immeasurable. As always with such a project, there are a few individuals who go beyond the call of duty. The soul and spirit of Ruth Browne, who may be the oldest historian in town while at the same time the youngest at heart, was inspirational. The amazing memories and detailed descriptions of the team of Roger Rivers and Edmond Trudeau put my brain cells to shame. The humor and unique perspective of Ed Morandi added another dimension to my viewpoint. Daniel J. Maloney Jr. helped the process with his expertise in database inventory. However, the enthusiastic support and tireless patience of Lorraine Maloney and Deborah Sprague of the North Adams Historical Society was the heart and soul of my endurance and execution that ultimately allowed this book to be possible. I also thank friends and colleagues Paula and Emiliano DeLaurentiis, who brought me to North Adams and introduced me to its civilized way of life. Finally, I can truly say that it is my mom's boundless love and confidence in my potential that instills me with the courage and imagination to pursue all my dreams.

INTRODUCTION

North Adams was originally the north village of the township of East Hoosuck, first settled c. 1740 and incorporated in 1776 as the town of Adams. In 1878, the north village split off and incorporated as the town of North Adams. In 1895, North Adams became a city. These are the historical facts but, as with any city, there are more than just facts that tell the story and life of a physical location.

North Adams has come to be a mental as well as a physical state, and many efforts have been made to define and describe this mental state. In the final analysis, it may be best defined in the captured images of its unique epochs of history. It may also be defined in the words of Samuel Adams, the patriot and signer of the Declaration of Independence whose name the city bears:

> The liberties of any country, the freedom of our civil constitution are worth defending at
> all hazards . . . we have received them as a fair inheritance.

So, too, our city's history and our rich environment are received by today's citizen as a fair inheritance.

The atmosphere of North Adams, from its birth in attempting to defend a remote British fort against all odds, was one of freedom. "Keep moving" could have been its motto. It may have been a vertical movement—as in the steeples professing freedom of worship. It may also have been a horizontal movement—along the many trails and railroads that brought settlers seeking freedom of enterprise and freedom from political and social restrictions. North Adams was founded by the bold and would not be maintained by the timid. The town-turned-city became an astonishing unity of folkways and culture. What began as a wilderness became a region of industrial climax. It stressed both individualism and mass production. Yet it always sensed its landscape of perennial frontiers, both physical and spiritual, as well as a strong belief in its own destiny. This belief was both optimistic and unruly in conditions of boundless wealth and terrific cyclical depression.

To travelers in our midst and to outside observers, North Adams has been a constantly changing enigma. It has been seen as a wilderness, a treasure of industry, a constant contest with nature, and a sprawling and lively city—the best of times, the worst of times. We have inherited a tradition of insistence on courage and honest hard work, a dream of a better future, a belief in education, a yearning for family, and a humor that has made difficulties more tolerable.

North Adams has experienced it all and has survived it all. We can truly say that among the cardinal virtues, it is hope we cherish most. In gathering these historic images, it is my desire that those who see them will have a deeper reverence and respect for home and, I trust, will join in the fulfillment of our hopes.

—Robert Campanile
March 2001

*Dedicated to all the photographers whose mind's eye
made these historic images possible.*

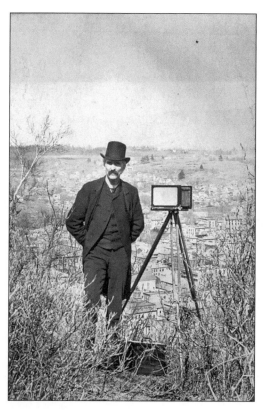

**A TURN-OF-THE-CENTURY
PHOTOGRAPHER.** George Stanley Blake
poses on Witt's Ledge, which overlooks the
city of North Adams.

One
MY HOMETOWN

NORTH ADAMS, 1841. One of the earliest images of North Adams depicts just what a hometown meant to most people. The covered bridge leads to a broad Main Street, which passes a cupola-topped gristmill and heads for the steepled churches—all nestled in a comforting valley.

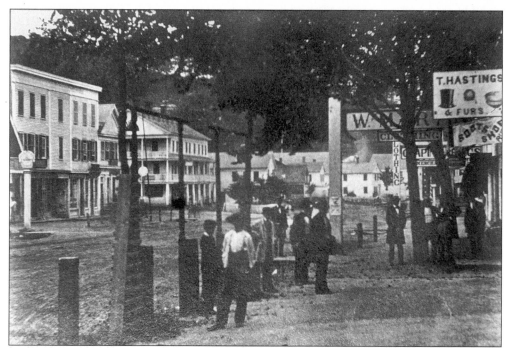

MAIN STREET, 1850. This may be the earliest image of Main Street, a place where shade trees grew beneath a calm sky. Everybody owned the street—rich and poor, adult and child. A town's main street symbolized the pulse of its people.

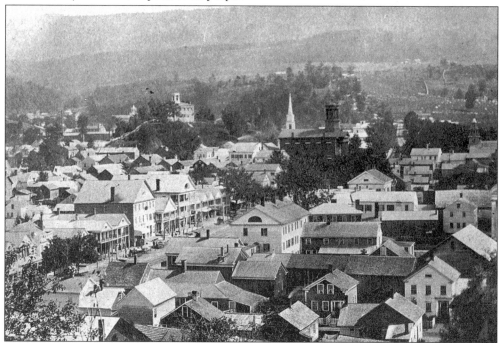

NORTH ADAMS, 1850–1860. The peaceful atmosphere in this image will soon be disturbed by a "house divided"—the Civil War. The railroad has arrived to bolster its thriving mill industry, and the famous Hoosac Tunnel project has begun.

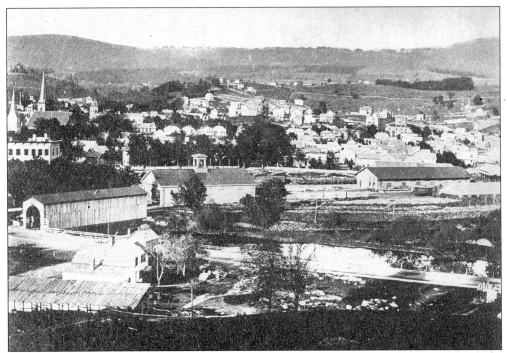

NORTH ADAMS, 1872. This view looks northeast, past the railroad yards. At the time this photograph was taken, thrift and progress characterized the northern section of Adams, which would become North Adams, and the citizens were already weaving a mosaic of different cultures.

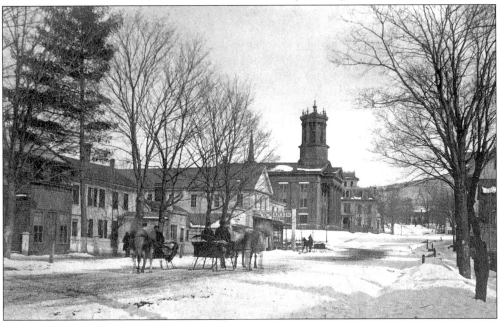

MAIN STREET, 1875. Citizens transport themselves via sleighs on Main Street. The dominant round tower is the old Baptist church. In 1875, the town was still three years away from gaining independence from Adams. The population of about 10,000 was increasing as a result of industrial prosperity.

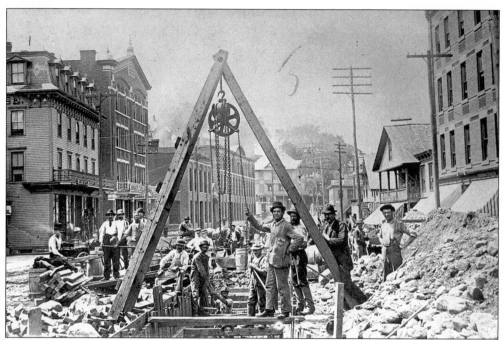

WORKING ON WATER AND SEWER LINES. In 1898, the town became a city. By the turn of the century, water and sewer lines were being placed. This photograph of Main Street shows the workers and their progress.

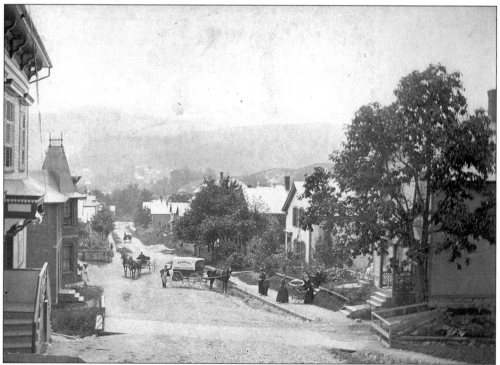

BROOKLYN STREET, 1889. In this view looking south down Brooklyn Street, the city has taken on its present-day look. The road, however, has not yet been paved.

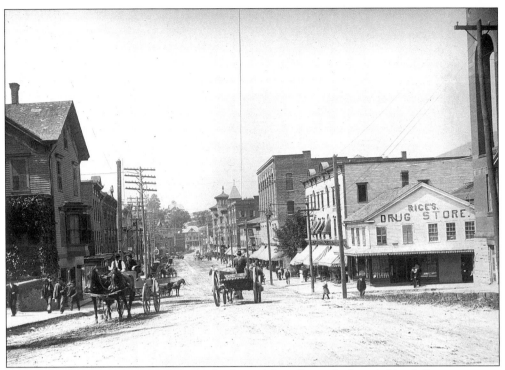

Main Street, 1899. This photograph shows Main Street before Ashland Street was cut through. Eagle Street is on the right in the foreground, with the famous Rice's Drug Store on the corner. The trolley tracks stopped halfway up Main Street.

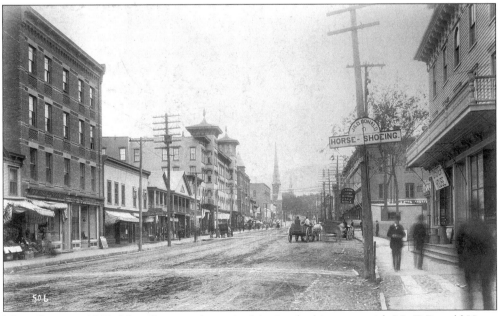

Main Street, 1900. Main Street is shown in this view looking east, with J & D Donald Horse Shoeing on the right. The twin towers on the left are atop the famous Wilson House hotel.

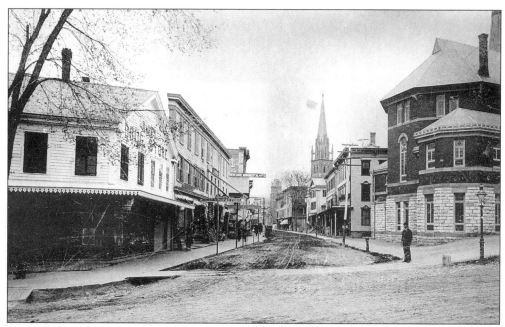

EAGLE STREET, BEFORE 1900. This view of Eagle Street was taken from Main Street. Jeremiah Colegrove deeded this road to the town in 1805. The layout and buildings of this quaint street reflect the history of North Adams. The narrow, curving layout is a vestige of the early years, and the buildings date from every major period in the city's history. Never as grand as Main Street, Eagle Street is a more intimate setting.

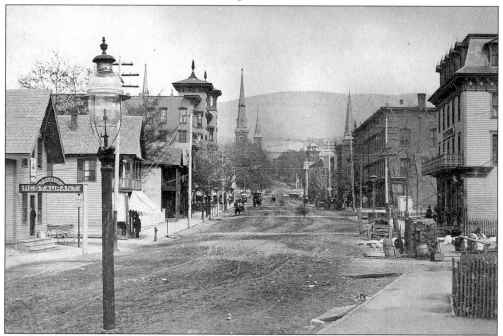

MAIN STREET, 1890s. Main Street is shown with gas lamps and wagons in this view looking east. The middle steeple in the distance is the Notre Dame church. In the left foreground is the restaurant of Peter Sorell, one of the first French Canadians to arrive in North Adams.

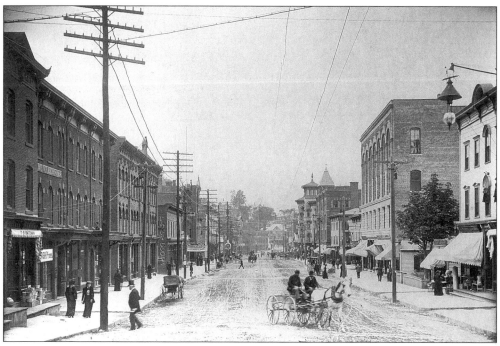

MAIN STREET, LATE 1800s. Looking west, this view shows Main Street with wagons and men wearing top hats on a busy afternoon.

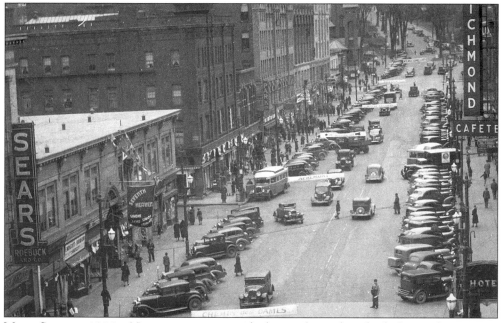

MAIN STREET, 1930s. Numerous cars are parked at traditional angles before parking meters were a part of everyday life. The city is very active. In the foreground on the left is Sears.

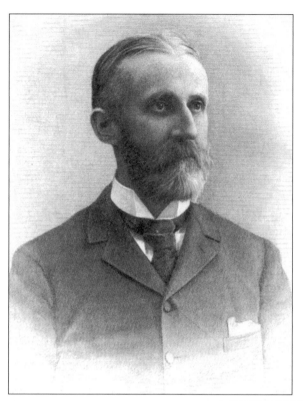

ALBERT HOUGHTON, FIRST MAYOR. The first mayor of North Adams was elected in 1895. The *Berkshire Democrat* newspaper had this to say: "Mr. Houghton is a genial, approachable man . . . a man of great executive ability. Any good cause has found in him a sure friend. The people of this young city are confident that his administration will be a notable one in the history of Massachusetts cities."

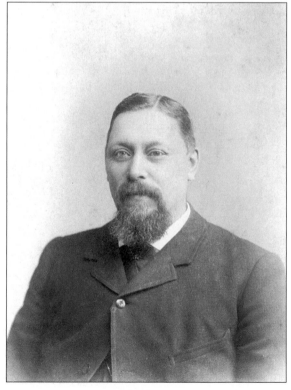

COUNCILMAN JAMES FLAGG. James Flagg, elected in 1895, was one of the first councilmen of North Adams. He was highly esteemed by the community for his ability, integrity, and public spiritedness. He was considered thoroughly conversant with the wants and growth of the city. He always took an active interest in public affairs and was a firm believer that good municipal government would add to the city's greatness and importance of its industries. As a member of the council, he suggested economy in public spending and the lowest possible tax rate. (Courtesy of the A.E. Hosley family.)

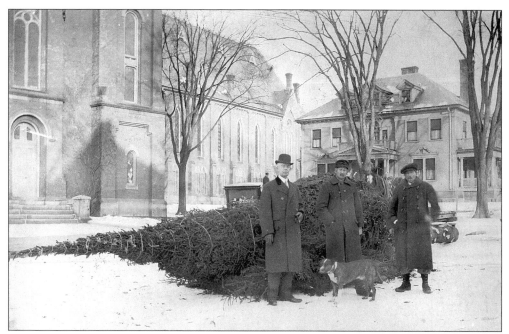

MAYOR BROWN AND THE CITY CHRISTMAS TREE, NOVEMBER 1914. Mayor Wallace Brown (left) served as mayor from 1913 to 1915. He is shown inspecting the city's annual Christmas tree, located in Monument Square.

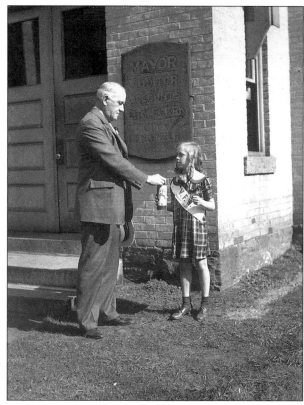

MAYOR O'HARA (1937–1940). Shown in front of the old city hall, Mayor Francis J. O'Hara helps a dedicated young citizen who is collecting for the Veterans of Foreign Wars.

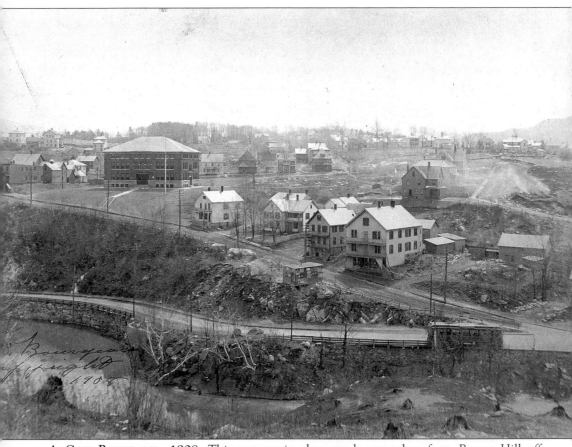

A City Panorama, 1908. This panoramic photograph was taken from Beaver Hill off Franklin Street and Glen Avenue on April 5, 1908. Beaver Street (the lower road to the left)

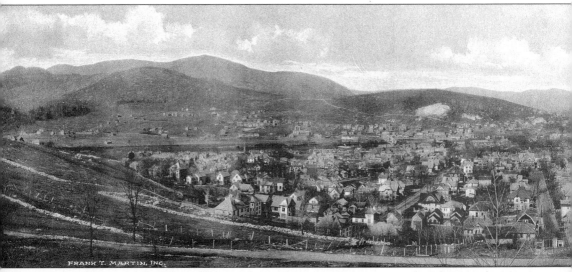

A City Panorama, 1913. This image captures the nestling of North Adams in the Hoosac

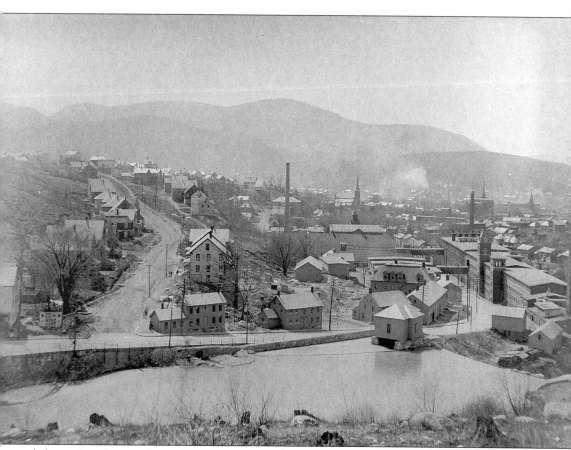

led to a French Canadian mill worker's community.

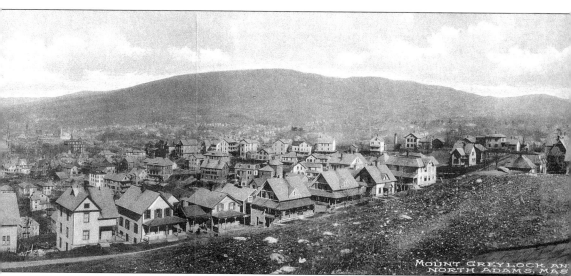

Valley. Mount Greylock is in the background.

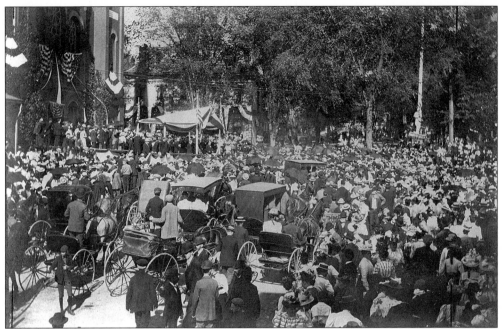

PRES. WILLIAM MCKINLEY VISITS NORTH ADAMS. Pres. William McKinley, who was spending a few days with his friend W.B. Plunkett in Adams, came to North Adams on June 26, 1899, to receive homage of its citizens. A band met McKinley's carriage on Church Street and escorted him to the reviewing stand at Monument Square.

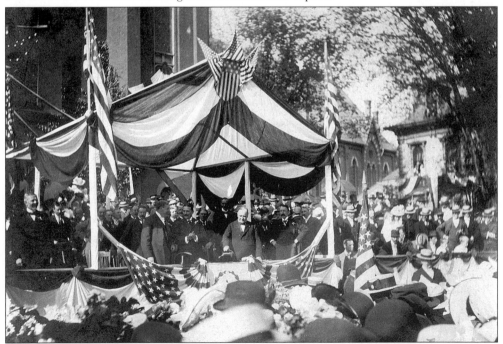

MCKINLEY AT MONUMENT SQUARE. McKinley is shown addressing the citizens of North Adams at Monument Square in front of the Baptist church. There he received a procession of schoolchildren and local societies who crowded in close with carriages to hear him.

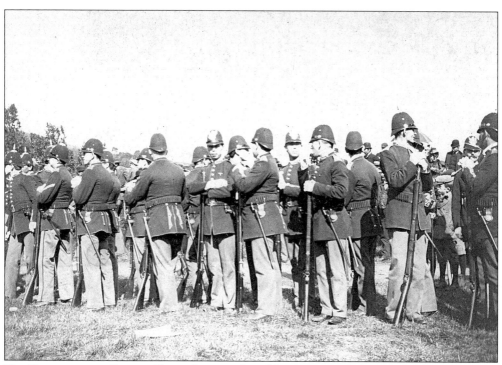

THE PRESIDENTIAL GUARD. Shown here are the soldiers who guarded McKinley during his visit.

AN OLD POLLING PLACE. This undated photograph of a building on Houghton and Brooklyn Streets shows an early polling place in North Adams. The building has served as a library and as a number of variety stores through the years. Today, it is a residence.

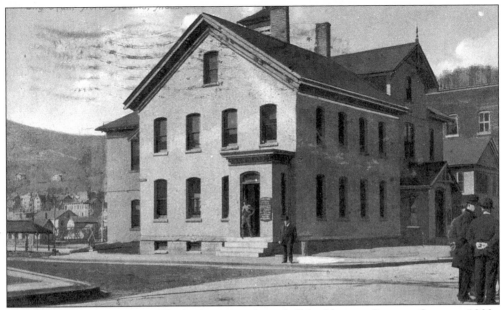

THE ORIGINAL CITY HALL. This is the original city hall building on Summer Street c. 1900.

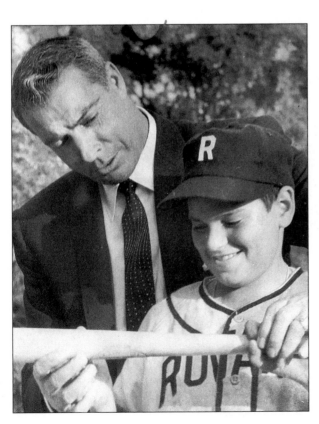

"JOLTIN' JOE" AND "THE KID." Hall of Famer Joe Dimaggio gives batting tips in 1959. Little did he know that "the Kid," John Barrett III, would later hit his share of home runs as mayor of North Adams. Barrett is the longest running mayor in North Adams history. (Courtesy of Mayor John Barrett III.)

Two

GUARDIANS
AND SURVIVORS

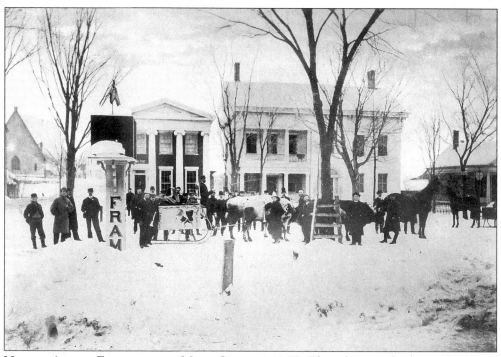

NORTH ADAMS FIREFIGHTERS, MAIN STREET, 1865. This photograph shows the North Adams fire apparatus of Civil War days—a horse and hand pump, which is drawn by two yoke of oxen. The pump is flanked by some of the town's early firemen. One of them (left) is holding fireman's trumpet.

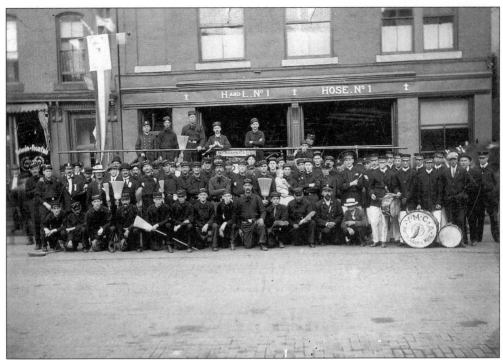

HOSE NO. 1 FIREFIGHTERS, 1900. This image was taken in front of the State Street station, which kept eight horses.

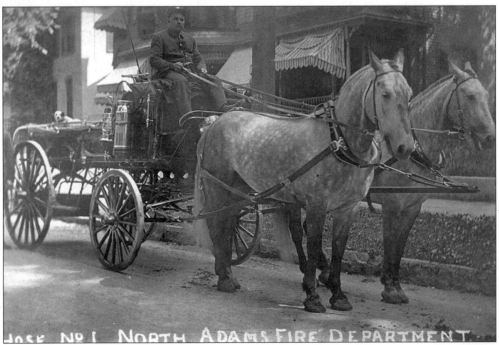

HOSE NO. 1 FIRE WAGON. A classic late-1800s fire wagon is shown ready for action with the traditional mascot seated in back.

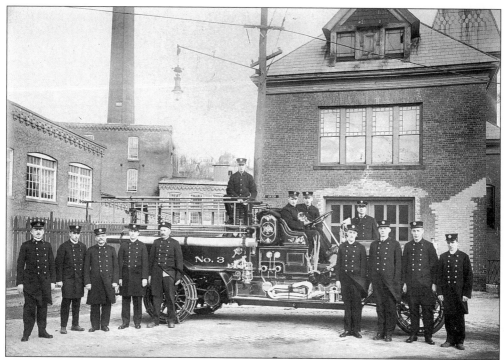

HOSE NO. 3. The North Adams Fire Department has always been considered efficient and enthusiastic to a remarkable degree. This is Hose No. 3 at the Union Street station.

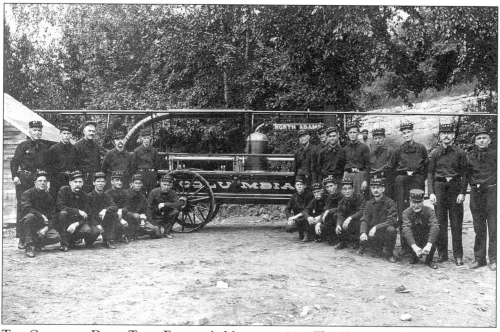

THE COLUMBIA DRILL TEAM FIREMEN'S MUSTER, 1900. The 25-man Columbia Drill Team is shown on Canal Street in North Adams. Firemen's muster games were a popular sport around the turn of the century. The faster they would pump, the farther the water would go, and that would determine the winner.

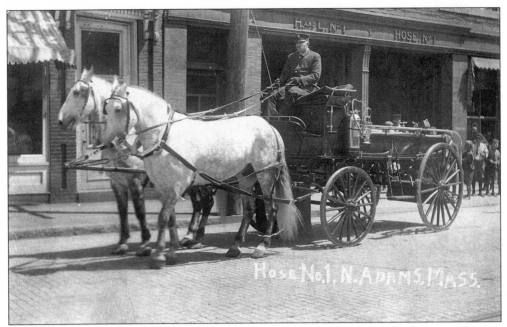

HOSE NO. 1, 1900. Around the turn of the century, a chief engineer received an annual salary of $900 and a fireman received $65. The apparatus consisted of two four-wheeled hose carriages, a two-wheeled horse cart, a two-horse hose wagon, a hook-and-ladder truck, and 4,700 feet of hose.

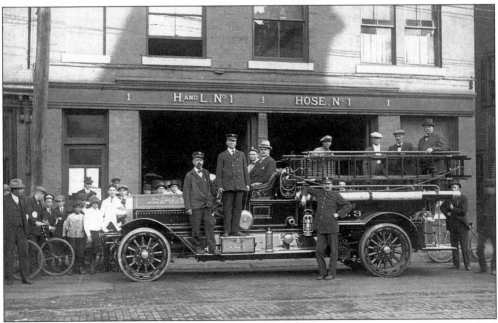

HOSE NO. 1, 1916. Chief Henry J. Montgomery is shown standing on board this hook-and-ladder truck, with Mayor John W. Gale (wearing a soft hat) in the driver's seat.

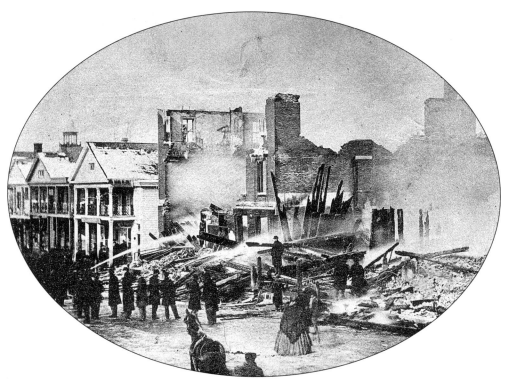

THE ARCADE FIRE, 1865. This very early photograph documents the famous arcade building fire of 1865.

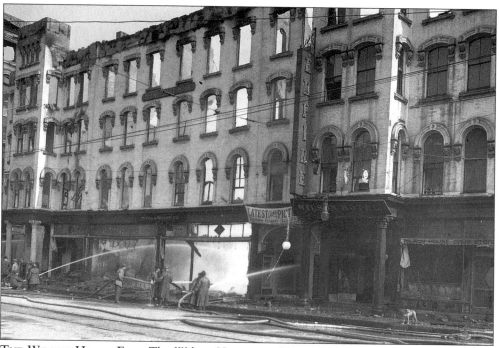

THE WILSON HOUSE FIRE. The Wilson House grand hotel, built in 1866, is shown in flames only months after Theodore Roosevelt spoke at the hotel in 1912.

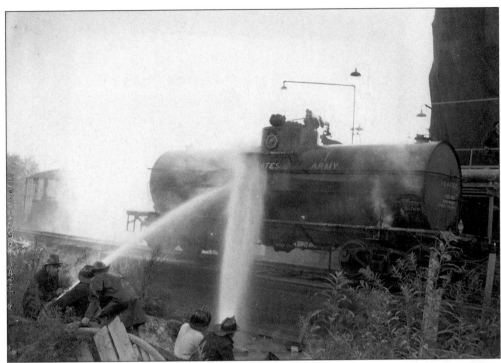

A TANKER FIRE, C. 1950. Firefighters are shown battling a dangerous chemical fire on a U.S. Army tanker car.

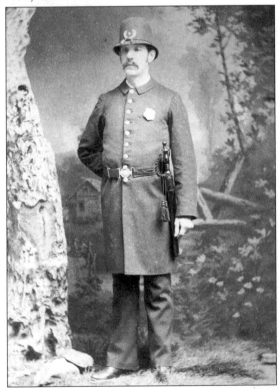

PATROLMAN HENRY CHARLES RAND, c. 1885. Fifteen stalwart men, dressed in neat uniforms of blue, served North Adams. It was said that only one qualification kept any man a member of the North Adams Police Department—strict loyalty to duty.

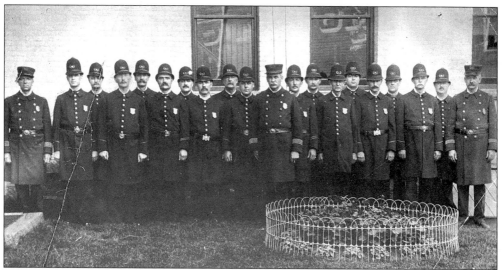

POLICE DEPARTMENT, 1900. A well-equipped and secure police station on State Street served as the headquarters for the department. A Gamwell electric system of police signals was part of the police protection of the city.

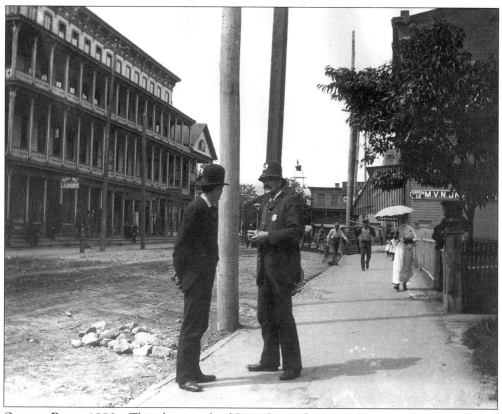

ON THE BEAT, 1890s. This photograph of State Street shows a policeman who is believed to be either Patrick Craven or William Regan. The grand Richmond Hotel is across the street.

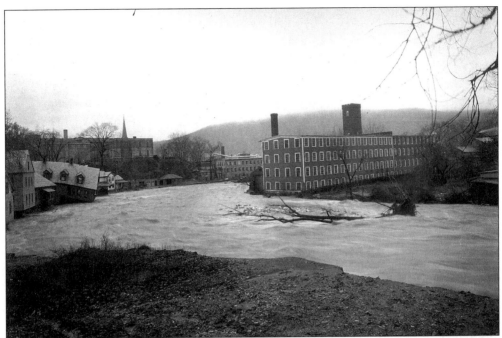

THE 1927 FLOOD. On November 4, 1927, the street and 10 homes were swept away in Willow Dell when a wall gave way behind the homes. The routine flooding of the Hoosic River caused much destruction in the 1800s and 1900s.

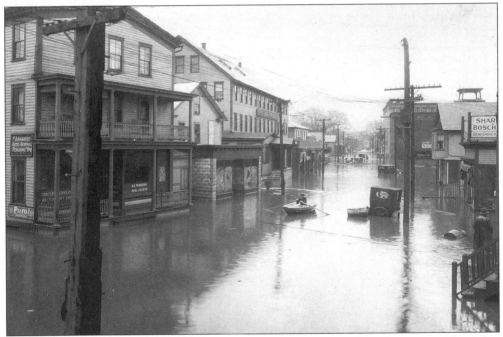

THE 1927 FLOOD, ASHLAND STREET. The Hoosic River floods Ashland Street on November 4, 1927. Several motorists had to swim to safety. The worst part of the flooding was the spreading of disease from the waste water that was dumped into the river. The floods carried it into the streets and houses.

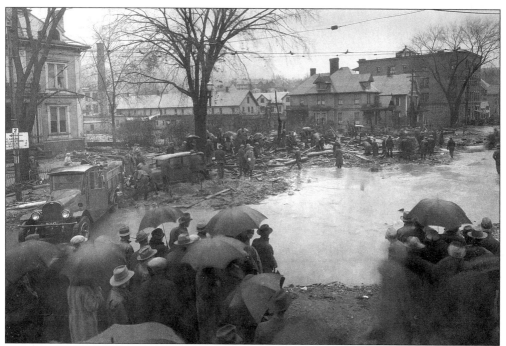

THE 1927 FLOOD, EAGLE STREET. This image shows the removal of many automobiles on Eagle Street, where more than 50 cars were stalled on the night of the flood.

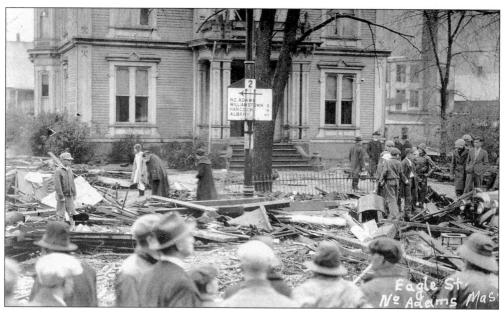

THE 1927 FLOOD. The following five photographs vividly tell the story of the havoc brought in and about North Adams by the flood of November 3 and 4, 1927. A scene of desolation unfolded before the camera at dawn.

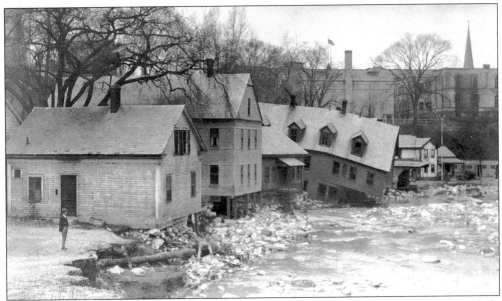

The Willow Dell Area. Being located close to the river meant no escape when it flooded

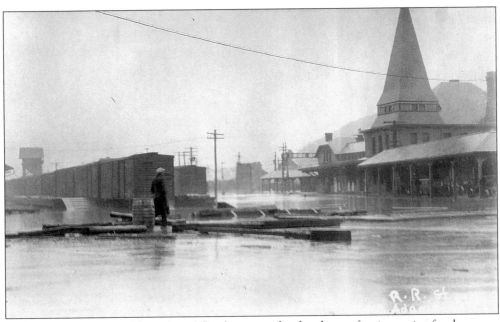

The Railroad Yard. The rail yard flooding caused a shutdown of train service for days.

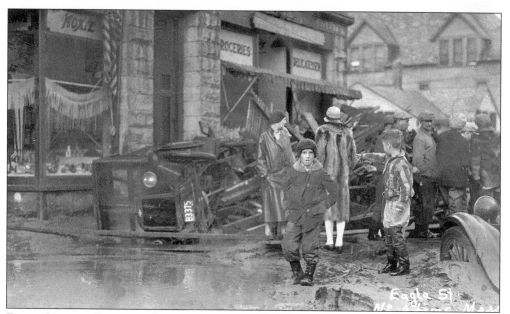

EAGLE STREET. Citizens gather in amazement at the destruction on Eagle Street.

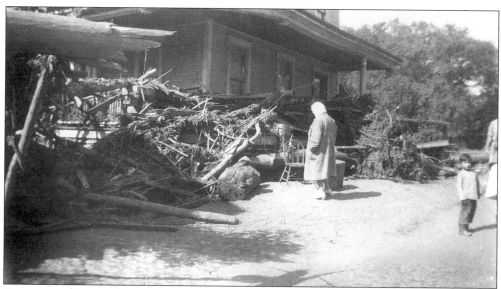

CONTEMPLATING LOSSES. A man looks on with despair at the loss of property.

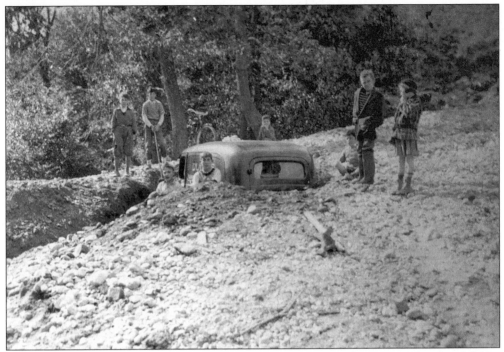

LANDSLIDE! This picture shows the result of a landslide on March 18, 1936. Mud and debris were piled 10 feet high across the streets.

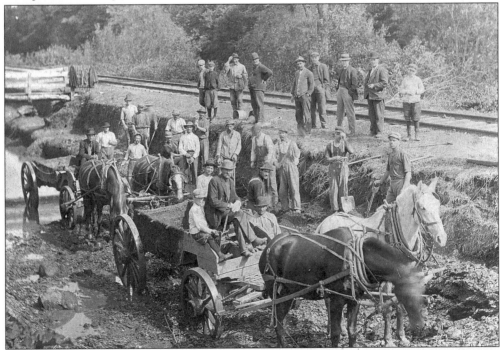

FLOOD CONTROL. This late-1800s photograph shows the attempts that were made to control the floodwaters. It took until the 1950s before the city finally built the control chutes that eventually ended the flood nightmares.

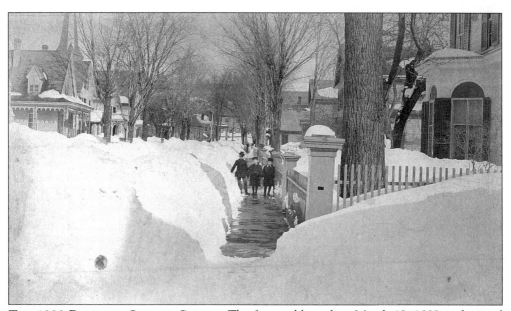

THE 1888 BLIZZARD, SUMMER STREET. The famous blizzard on March 13, 1888, is depicted in this photograph of three children strolling past piles of shoveled snow on Summer Street.

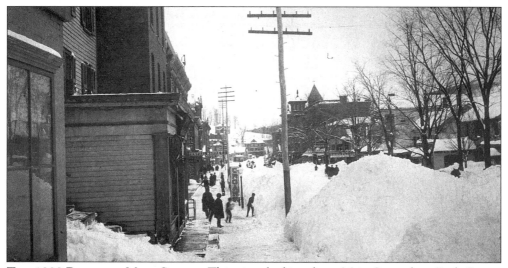

THE 1888 BLIZZARD, MAIN STREET. This view, looking down Main Street from Eagle Street, shows the effects of the March 1888 blizzard. The snow piles were taller than humans.

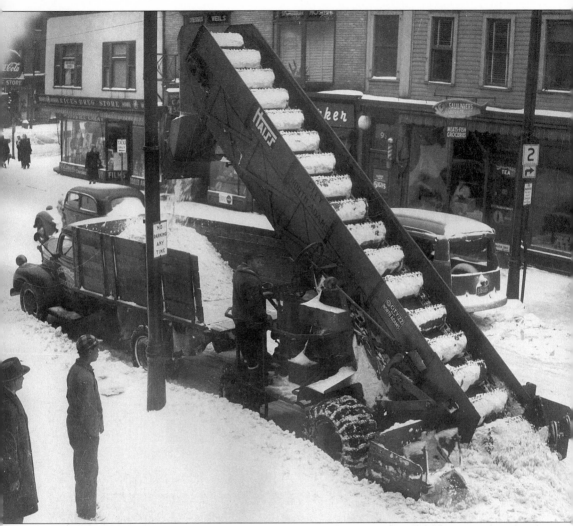

SNOW REMOVAL. Keeping the streets clear through the New England winters has always been a priority of the city. This is a typical snow removal scene of the 1950s.

Three
FEEDING THE FAMILY

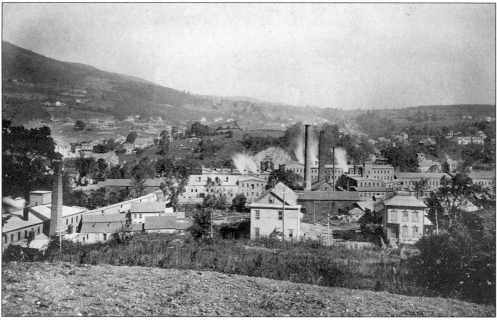

THE ARNOLD PRINT WORKS. The North Adams work ethic is what made the city one of survivors. The Arnold Print Works, seen here from Furnace Hill, was built in 1861 between the north and south branches of the Hoosic River. It was the largest print works in the United States during the city's economic heyday from the Civil War (when it made Union uniforms) until the 20th century. The fortune of the print works and the city went hand in hand. Furnace Hill is also the location of the North Adams Iron Works, which produced pig iron for the Union ironclad *Monitor* during the Civil War.

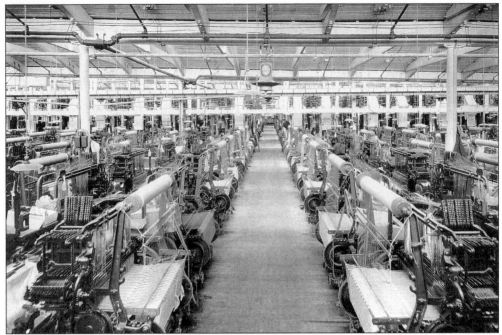

INSIDE THE ARNOLD PRINT WORKS. The Arnold Print Works employed more than 3,000 workers. It was purely a North Adams product, inseparably connected with the city and instrumental in shaping the commercial supremacy of North Adams in western Massachusetts.

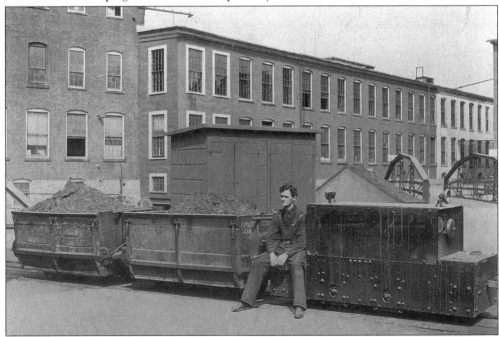

THE ARNOLD PRINT WORKS, 1916. This photograph shows the print works yard and the coal conveyer that ran through the yard. Seated on the train is Charles Daniels, who symbolized the many hard workers of North Adams. Daniels worked hard well into his eighties before retiring. (Courtesy of Paul Gigliotti.)

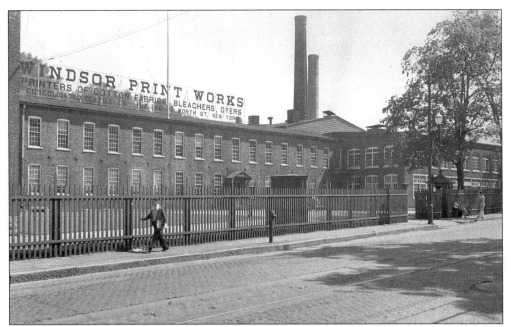

THE WINDSOR PRINT WORKS. Located on Union Street, this industry started up in the late 1800s and was a complete dyeing, printing, and bleaching fabric industry. It started the first napping of printed cotton flannel in the United States and was noted as the leader in style and texture.

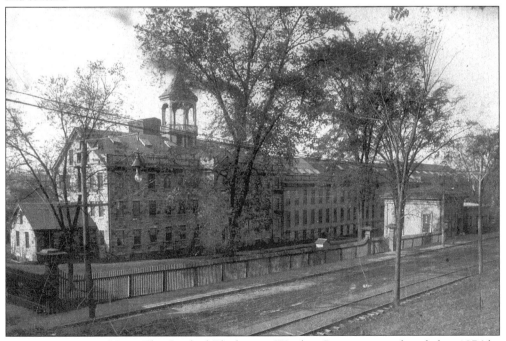

THE BLACKINTON MILL. The Sanford Blackinton Woolen Company was founded in 1876 by Sanford Blackinton, one of the industrial pioneers of North Adams. In order to house his workers and management, Blackinton created an entire village in an area that later became known simply as Blackinton.

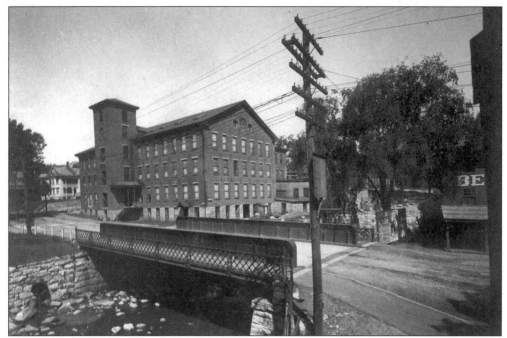

THE OLD EAGLE MILL. This photograph shows one of the old iron bridges built in North Adams during the 19th and 20th centuries. It spans the Hoosic River at Eagle Street and leads to the Old Eagle Mill. The mill burned down in the 1970s.

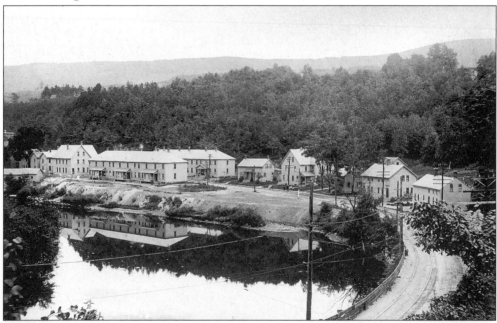

THE BEAVER, 1919. This view shows Beaver Street, one of the more unusual neighborhoods of North Adams in its early years. The community was made up of French Canadians who came to work in the cotton mills. The area is the only one named after an animal in North Adams. There seemed to be a constant battle between humans and the beaver dams that would cause an overflow on the Hudson Brook. A truce was finally agreed upon.

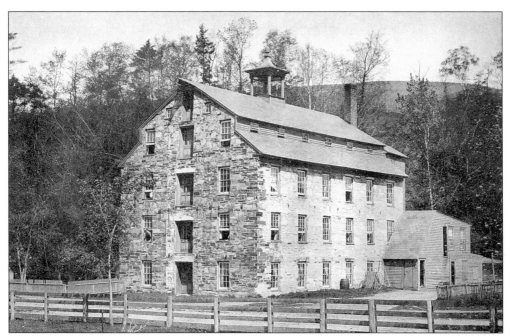

THE OLD STONE MILL. This mill, located on River and Houghton Streets, was erected in 1831. It manufactured print cloths. During the course of its history, it changed hands many times, eventually becoming the Freeman Manufacturing Company. Razed in the 1890s, the stone-style mill with cupola represented a lost art in mill construction.

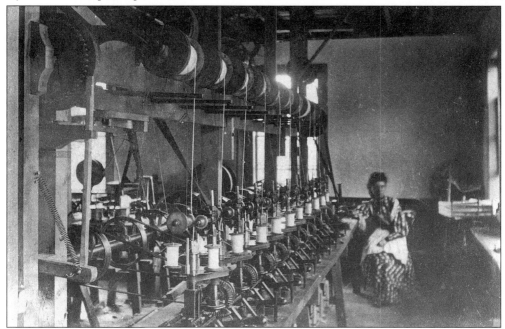

THE BLASTING CAPS FACTORY. This late-1800s photograph shows the machine that insulated wires for the first "safe" nitroglycerin exploders. The blasting caps were made at a small factory by Charles and Isaac Browne. The building is still standing on South Church Street. It became instrumental in the successful construction of the Hoosac Tunnel.

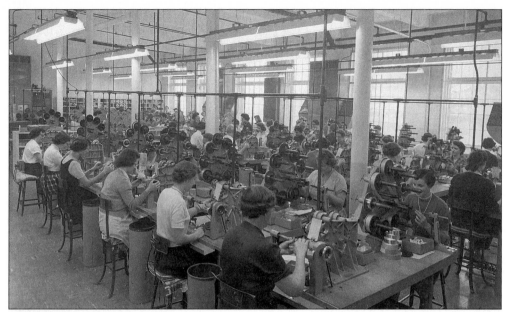

SPRAGUE ELECTRIC. The Sprague Electric Company began operation in 1926. During the Great Depression, the company made steady progress. In 1943, when the Arnold Print Works closed, the company moved into a large building complex. Sprague Electric was a major employer in North Adams until it closed in 1985. The complex later became the Massachusetts Museum of Contemporary Art, the largest contemporary art museum in the world.

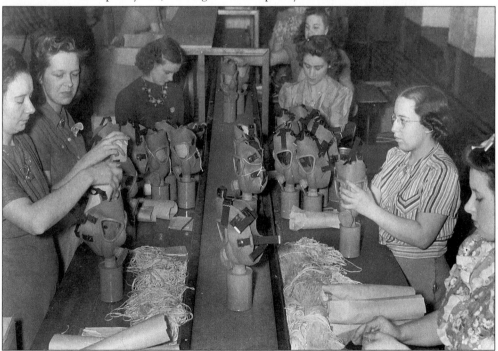

GAS MASK PRODUCTION. During World War II, the Wall-Streeter Shoe Company and Sprague Specialties teamed up to manufacture gas masks. One made the leather and the other made the metal.

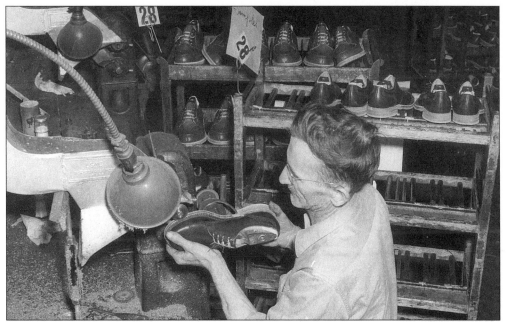

THE WALL-STREETER SHOE COMPANY. James Wall as a youngster had a desire to manufacture. He began Streeter-System Shoes with Ed Streeter and Albert Doyle in 1912. They made quality shoes at popular prices. In 1938, his son Robert Wall joined the company and eventually became a shoemaker and took over the company that became Wall-Streeter. The company continued until 1973. This photograph shows Alfred Viens putting on finishing touches.

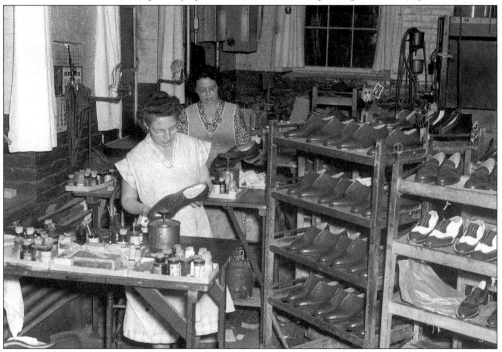

FINAL STEP. Final steps at Wall-Streeter show Valida Columbus and Louise Wells inspecting before boxing the shoes.

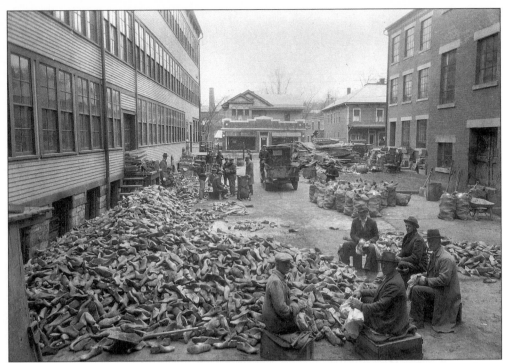

THE FLOOD OF 1927, WALL-STREETER SHOE COMPANY. Wall-Streeter employees are shown drying and cleaning the shoe lasts after the 1927 flood.

SANFORD BLACKINTON. Sanford Blackinton was one of the wealthiest and most influential manufacturers in western Massachusetts of his day. He was one of the first "bosses" to move away from the mill community he created. It was said he would leave his cane at the office to let everyone know he was not away for long. His mansion, built in 1869, on the corner of Main and Church Streets became the city's library in 1898.

THE PHOENIX FLOUR MILLS. This *c.* 1900 photograph shows the large Phoenix Mill for flour, grain, meal, and feed manufacturing. It was located on Main Street, now the site of the Northern Berkshire Mental Health Building.

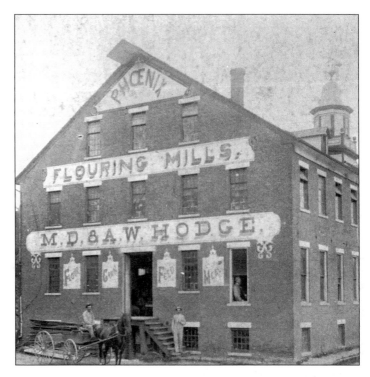

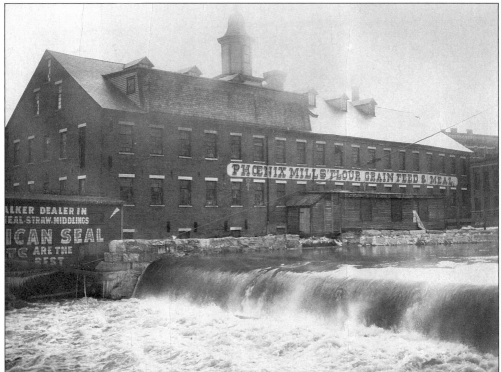

THE PHOENIX MILL AND RIVER. The same Phoenix Mill is shown from the west side, with the Hoosic River rushing by.

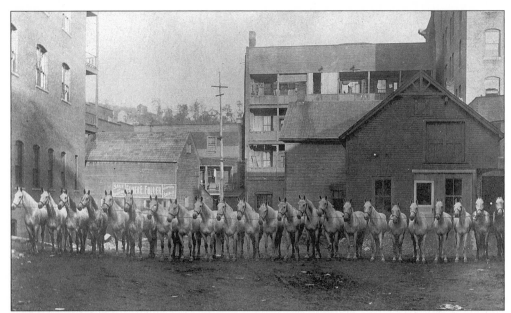

J.H. FLAGG'S LIVERY. J.H. Flagg's livery and boarding stable on 57 Main Street was one of the oldest establishments of its kind in western Massachusetts. This photograph shows the livery c. 1900, when it was already about 40 years old. J.H. Flagg would become one of the first city councilmen and took great interest in public affairs.

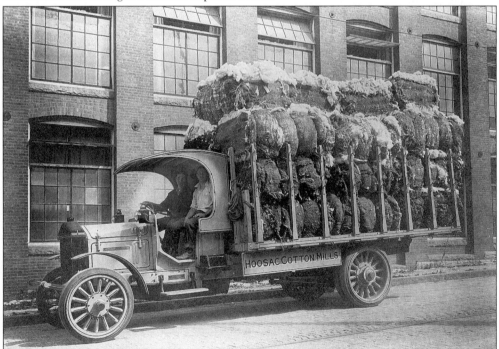

PIERCE ARROW. Telesphore Dumouchel is shown driving the first truck for the Hoosic Cotton Mill. It carried raw cotton from the rail yard to the mill. It was used in parades to carry floats because of the flatbed back. Note the hard tires and the oil lamps for headlights. (Courtesy of Lawrence Phelps.)

46

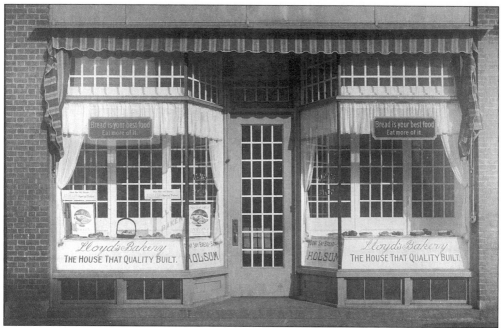

LLOYD'S BAKERY, 1920S. The famous Lloyd's Bakery on River and Houghton Streets is shown in the 1920s. It was a typical family-owned and family-operated business of North Adams and operated on a retail and wholesale basis.

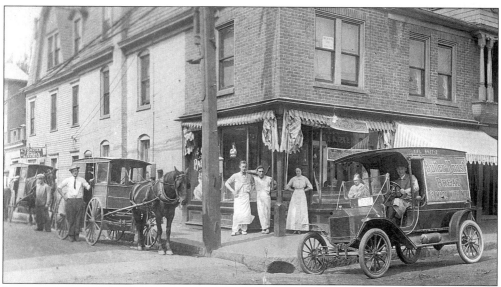

LLOYD'S BAKERY. This is the bakery's horse Molly and the truck delivery wagons. Holsum was the brand named the business used in selling its bakery products and baked beans. In this image, Ralph Lloyd is in the truck at the wheel. Harold Lloyd is standing near the wagon with his wife, Grace Lloyd, in the doorway.

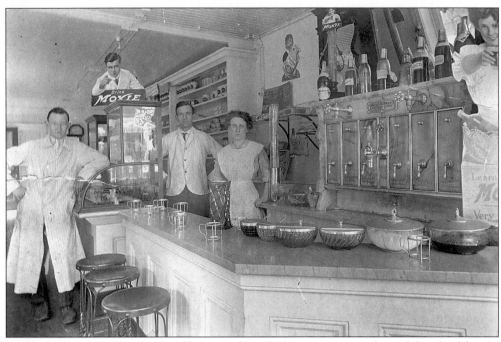

AN OLD-TIME SODA FOUNTAIN. Shown at the soda fountain are members of the Lloyd family.

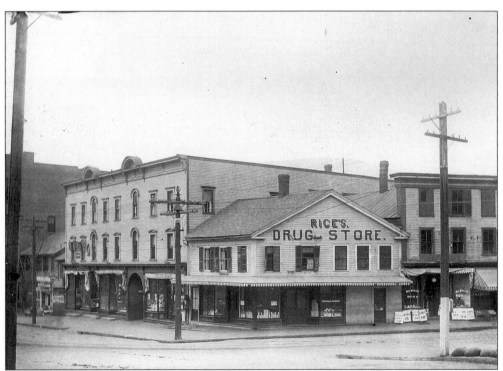

RICE'S DRUG STORE. Established in 1866, Rice's Drug Store is shown here just before the turn of the century. Located on the corner of Main and Eagle Streets, the store continued on until the 1960s. The upstairs contained Mrs. Tucker's millinery shop at the time of the photograph.

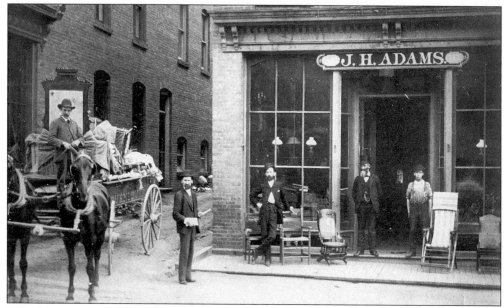

J.H. ADAMS, 1872. This photograph shows the handsome store of J.H. Adams at 113 Main Street. The furniture store was established in the mid-1800s and eventually sold to W. Burdett in 1894. It was always a very successful business under both owners.

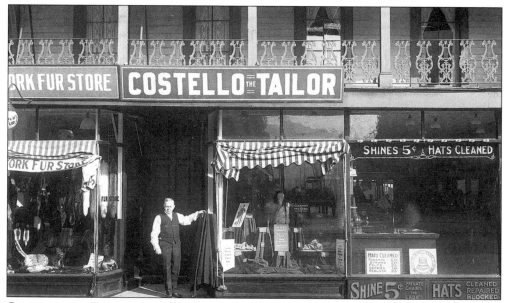

COSTELLO THE TAILOR. Costello proudly stands in front of his store, located on Main Street.

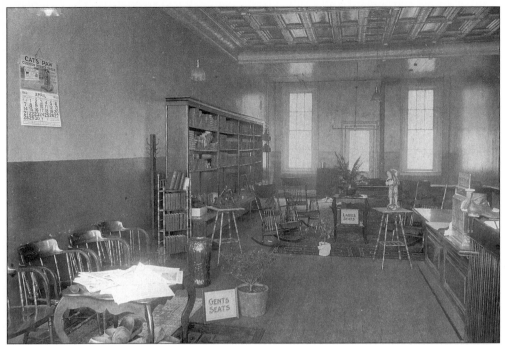

THE PARTENOPE SHOE SHOP, 1912. This interesting photograph is full of information. The calender on the wall shows the date of April 1912. Note the signs designating the gents' and ladies' shoeshine areas. The period decor is seen in detail. (Courtesy of Venice Partenope.)

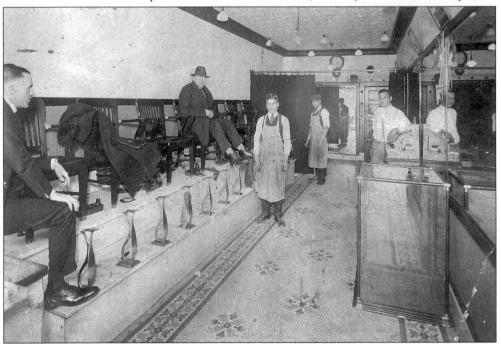

THE FRONT OF THE SHOESHINE PARLOR, 1912. Peter Mazza, in center with apron, is ready to serve his customers in this front view of the parlor. The clock on the wall seems to indicate late afternoon. (Courtesy of Venice Partenope.)

THE HOTEL BRUNSWICK, 1880. This small hotel was located on State Street next to the Hoosac Valley News and the fire department.

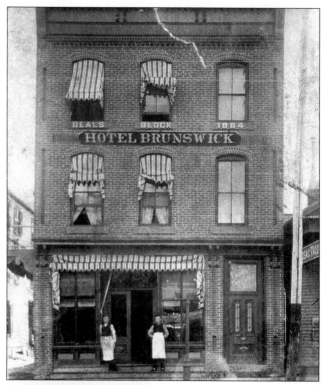

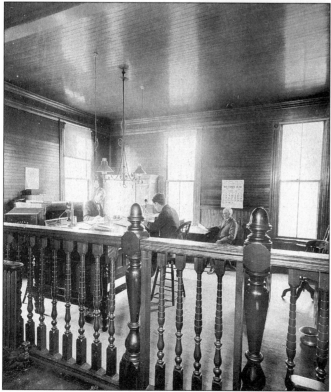

DIBBLE AND COMPANY, 1906. This interior view shows the offices of Dibble and Company. The company—which manufactured items such as doors, blinds, sashes, and boxes—was a leader in the business throughout western Massachusetts and southern Vermont. The firm was noted for its liberal business policy and public-spirited employees, and its financial standing was always considered excellent.

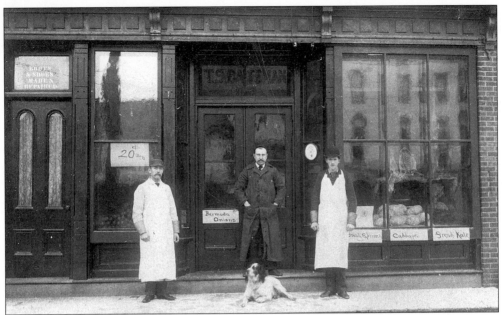

A GROCERY STORE. This undated photograph is a mystery, but it shows great character in the employees and the signs of merchandise being advertised.

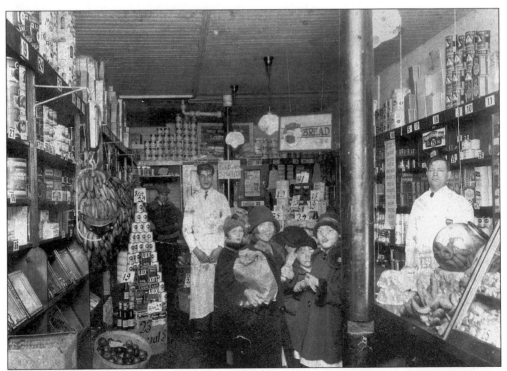

A GROCERY STORE, INTERIOR. A well-stocked grocery store is shown here with some young customers who are no doubt running an errand for Mom. Notice the hanging sign advertising bread for 9¢.

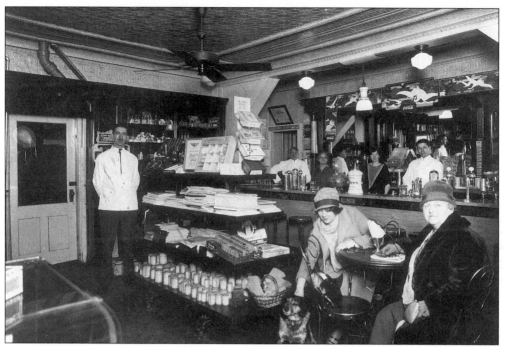

PEDERCINE'S DINER, 1930. This gathering was held at the neighborhood diner on State Street. The Pedercine family immigrated here from Brescia, Italy, and created a popular and friendly place for citizens of the city.

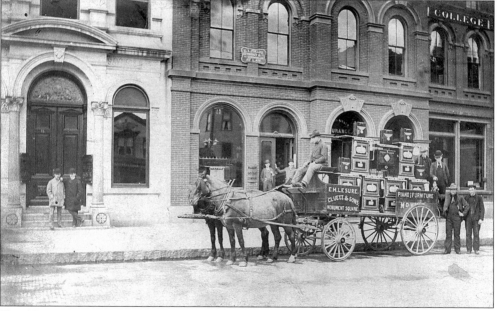

THE NORTH ADAMS GAS LIGHT COMPANY. A load of gas ranges is delivered a la carte to former North Adams Gas Light Company's salesroom. This photograph was taken in the early 1900s, when the office was located on the south side of Main Street. In the days of rapid progress and advancement, few companies were more important than the one that lit the streets and the homes.

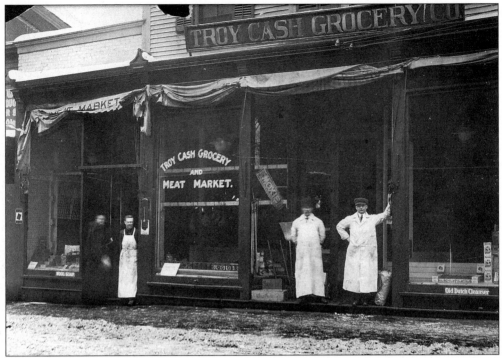

TROY CASH GROCERY. This 1909 photograph shows the workers of Troy Cash Grocery and Meat Market on Eagle Street. The proprietor was J. Rudnick.

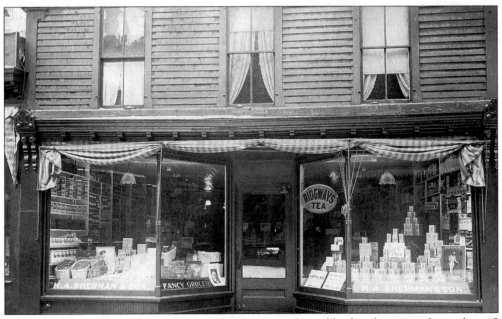

H.A. SHERMAN AND SON, C. 1920S. This is a typical neighborhood grocery, located at 15 Eagle Street.

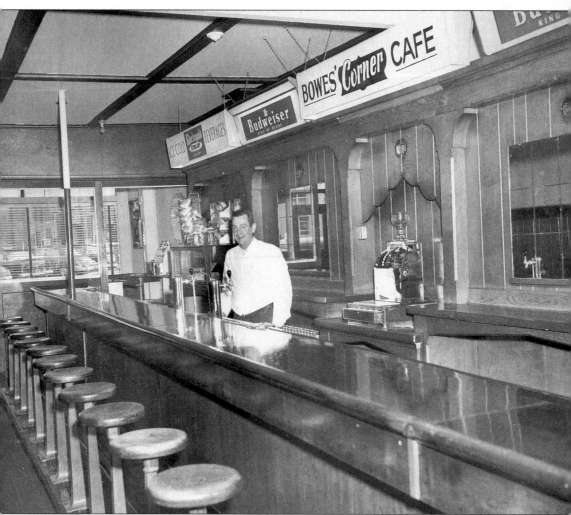

THE CORNER CAFE. Don Bowes, owner of the Corner Cafe, stands behind the bar in this picture from 1950. The cafe was located on the corner of Marshall and Main Streets before urban renewal.

A CODY AND CARPENTER ADVERTISEMENT. Cody and Carpenter, Eagle Street furniture dealers and undertakers, distributed these beautiful cards for advertisements. The original is in color. (Courtesy of Paul Gigliotti.)

Four

WEAVING A
CITY'S CULTURE

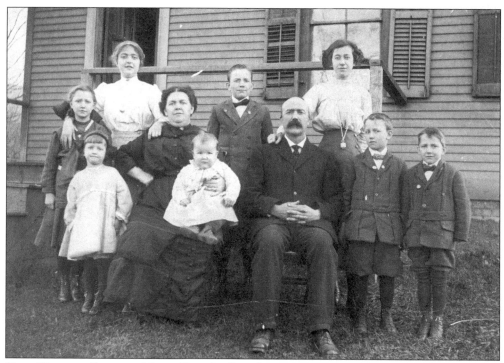

THE DELISLE FAMILY. Many French Canadian immigrants came from the village of St. Edouard, Canada, including Eugene and Pacifique (Circe) Delisle. Here they pose with their children in front of the family homestead on Brickyard Court. Eugene Delisle became superintendent of the North Adams Brick Company. (Courtesy of Lorraine Delisle Maloney.)

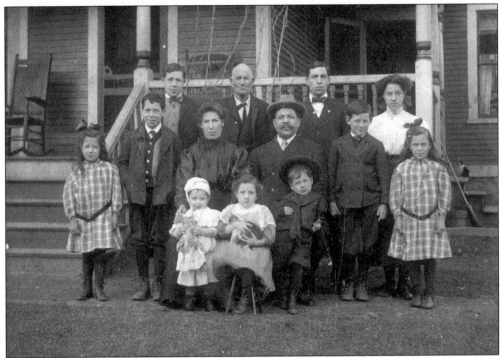

THE PARTENOPE FAMILY. Vincenzo and Vincenza (Maddalena) Partenope came to North Adams from Italy *c.* 1897. They are shown here posing with their children in front of the family home on Hospital Avenue. The home is still owned by members of the Partenope family. (Courtesy of Venice Partenope.)

THE BLACKINTON FAMILY. Delia Blackinton is shown with her grandchildren—Ruth Blackinton Browne (bottom), Marion Busby Pennington (upper left), Edward Busby (upper right).

THE BLACKINTON WOMEN, 1870s. The Blackinton women made their own important and unique contributions to the area. Their lives influenced the social and religious ways of life among the people of the village. Shown from left to right are Lillian, unidentified, Cherrie, Eugenia, Delia, and Ruth.

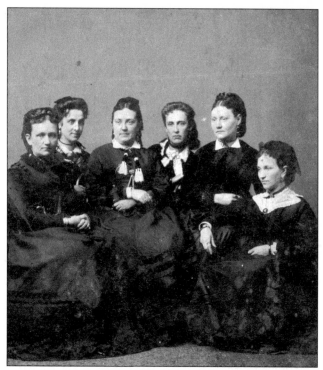

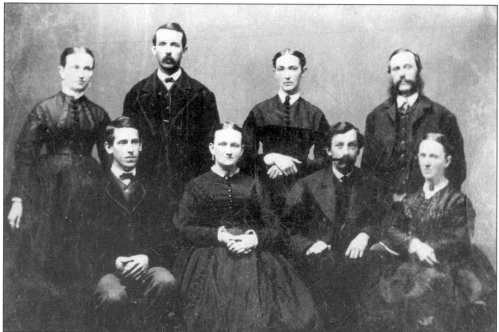

THE BLACKINTON FAMILY, 1870. The sons and daughters of John R. Blackinton are shown here. Blackinton was appointed postmaster in November 1856 in the newly established post office in Blackinton. John R. Blackinton was the brother of Sanford Blackinton, the wealthy industrialist who founded the mill and developed the Blackinton village, a predominately Welsh community.

THE ARCHER FAMILY. Oscar Archer was considered one of the most esteemed men of the city at the turn of the century. He was honored by having a library and school named after him. He started the first free public library in town in 1859. He died in 1919, only months short of his 90th birthday.

THE MANCUSO FAMILY. The Mancuso family immigrated to North Adams from Italy in the late 1800s. Many Italian immigrants lived in the Walnut Street area, which reminded them of the terraced slopes in their native country. (Courtesy of Venice Partenope.)

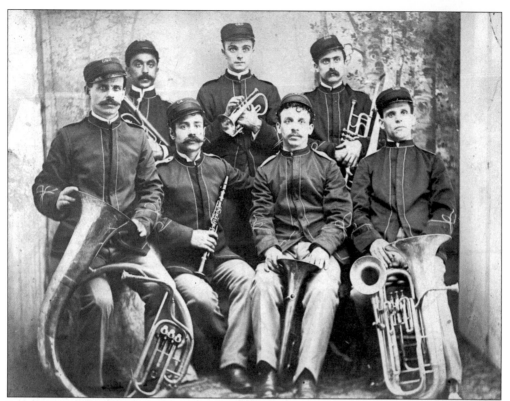

ITALIAN BANDS. Many ethnic groups would organize their own bands. These photographs show two small Italian bands. (Courtesy of Sons of Italy.)

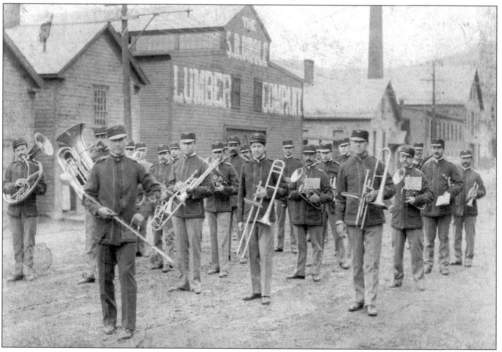

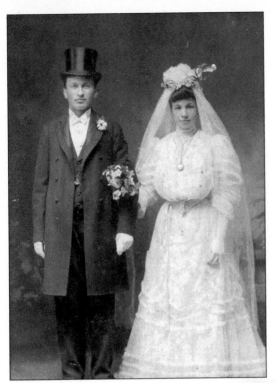

THE SHAPIRO WEDDING, 1905. Annie (Kronick) Shapiro and Samuel Shapiro pose for their wedding photograph. The wedding, one of the largest in North Adams at the time, was held in the Grand Army Hall. Samuel Shapiro started with a shoe store and then went into the horse business. He eventually created a successful automobile business, Shapiro Motors. (Courtesy of Lillian Shapiro Glickman.)

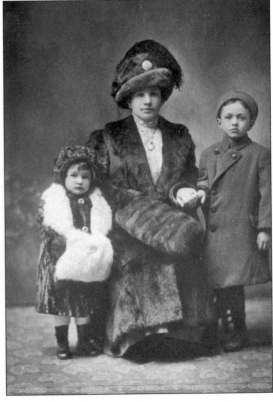

A FAMILY PHOTOGRAPH. "Aunt Annie" Shapiro, as she was affectionately known, was honorary president of the sisterhood in the Congregation Beth Israel. She is shown here with her daughter Rose Shapiro (Korn) and her son Louis Shapiro. (Courtesy of Lillian Shapiro Glickman.)

POSED. Sadie (Kronick) Ostrinsky came to North Adams from Poland in 1896. Her bubbly, stylish personality is evident in this famous hat. As the story goes, she lost the hat out a train window while returning to North Adams from Chicago. On a return trip, a conductor who found the hat returned it to her. (Courtesy of Lillian Shapiro Glickman.)

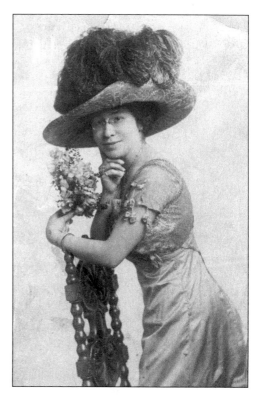

CHARLES AND LUCEY BUTLER, 1897. Charles Butler, along with another man, joined Frank Winfield Woolworth in opening a store in Lancaster, Pennsylvania, in 1879. The store was later called F.W. Woolworth & Company, the famous five-and-dime. (Courtesy of the A.E. Hosley family.)

ROSCOE AND ANNIE (GRANT) HOSLEY, 1887. Roscoe Hosely was the son of David E. Hosley and the father of David Grant Hosley, who was a basketball coach at Drury High School in the 1930s and 1940s. (Courtesy of the A.E. Hosley family.)

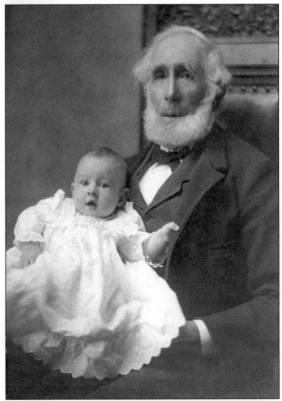

MAN AND BABY. David E. Hosley owned and operated a farm next to the Hoosac Tunnel during its construction. He is shown here holding his grandson David Grant Hosley in 1899. (Courtesy of the A.E. Hosley family.)

THREE SISTERS. Maria, Albina, and Colombe Bombardier—daughters of French Canadian immigrants Oscar and Emma (Guertin) Bombardier—are shown in this early-1900s photograph. All three sisters and Maria's husband, Jean Baptiste Durivage, died in October 1918 during the great worldwide influenza epidemic. (Courtesy of Lorraine Delisle Maloney.)

MAN AND CAR. Aimee Delisle proudly poses with the family automobile, a green 1928 Studebaker. (Courtesy of Lorraine Delisle Maloney.)

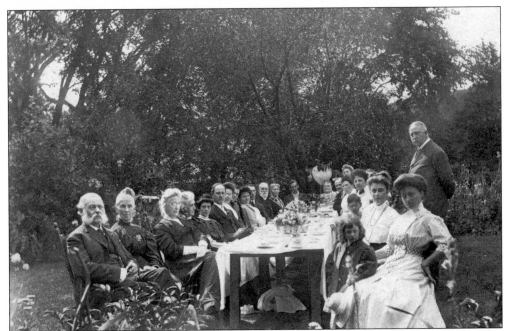

POWER LUNCH. The Blackintons, the Browns, the Archers, the Busbys, the Millards, the Wellses, the Waterhouses, and others share a meal at a gathering that we can bet contained some interesting conversation.

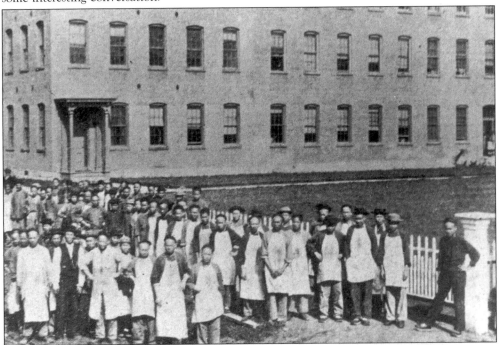

CHINESE WORKERS, 1870. These workers were brought in to work at the C.T. Sampson Manufacturing Company in 1870 following a strike by union workers. Here the workers pose outside the factory, which once stood opposite the building that is now the Massachusetts Museum of Contemporary Art on Marshall Street.

Five

A DAY IN THE LIFE

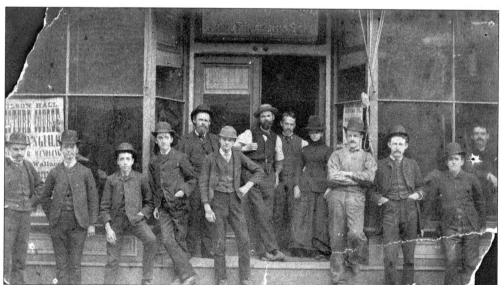

THE OLD TRANSCRIPT OFFICE. Recording the events of everyday life, this paper was established under the title of the *Adams Transcript* in 1843 by John Briggs with 600 subscribers. It later merged with the *Hoosac Valley News* and the title was changed to the *Transcript and News*. With the division of the town of Adams, the title was changed to the *North Adams Transcript*.

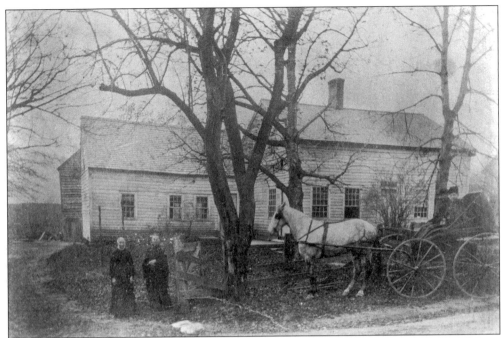

THE OLD BLACKINTON HOUSE. This mid-1800s photograph shows the Blackinton house, which was eventually replaced by the first Mark Hopkins School in the late 1890s. The location is on the corner of Church and Blackinton Streets. Today, the Massachusetts College of Liberal Arts admissions office stands on the site.

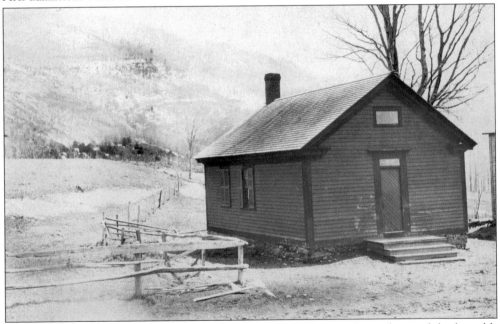

THE EAST MOUNTAIN SCHOOL. This building on East Mountain housed one of the last old-time schools in the area. The first schoolhouse in the North Adams village was opened c. 1800 on the porch of the old meetinghouse on Church Hill (East Main Street). Rebecca Morse was the teacher.

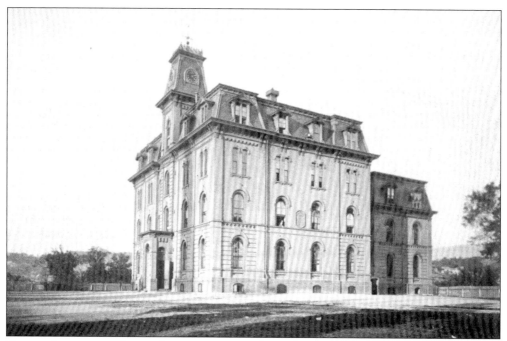

DRURY ACADEMY. Of secondary importance only to churches were the schools. The first real impetus to North Adams education was given in 1840 by Nathan Drury, who gave $3,000 for the founding of a school to be known as Drury Academy. First conducted as a private school, it was converted to a free high school in 1851.

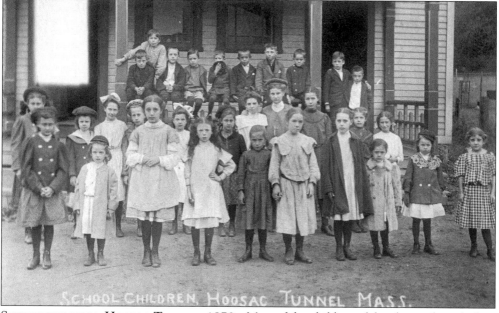

SCHOOLCHILDREN, HOOSAC TUNNEL, 1870s. Most of the children of this day graduated when they were between 11 and 14 years old. Those who could work were taken from the schools young and made to do so. Male teachers earned $8 to $12 per month, and female teachers earned $1 to $2 per week. Both salaries included board.

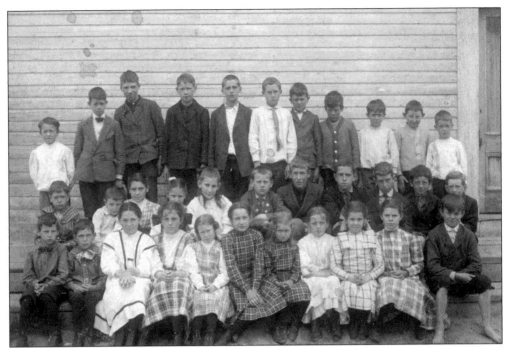

WALDEN SCHOOLCHILDREN. This school was located on the corner of West Shaft Road and Church Street. The photograph is not dated, but the attire indicates that it was taken *c.* 1900. Notice the shoeless boy (front row, far right).

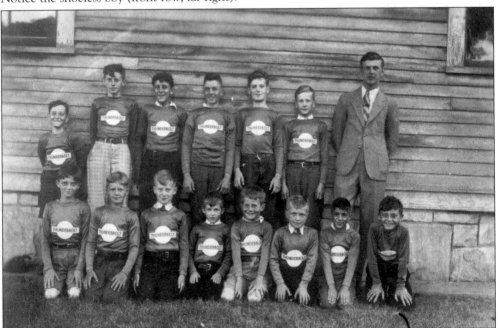

THE NORTH ADAMS BOYS' CLUB. After-school clubs offered many activities. This is the Thunderbolt Ski Club, the members of which are wearing blue sweaters that bear the white emblem of the club. The clubs, which were started as an experiment, proved so popular that many more were organized. (Courtesy of Doris Rennell.)

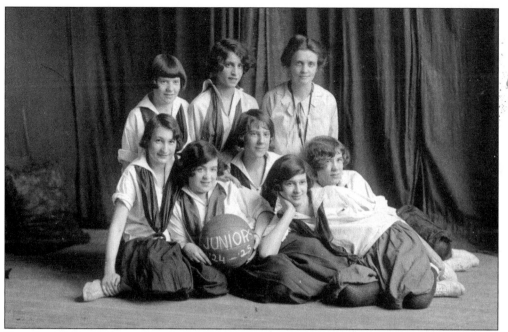

THE GIRLS' BASKETBALL TEAM. Sporting activities have always been an important part of the lives of North Adams children. This is the Drury High School girls' junior basketball team of 1924–1925.

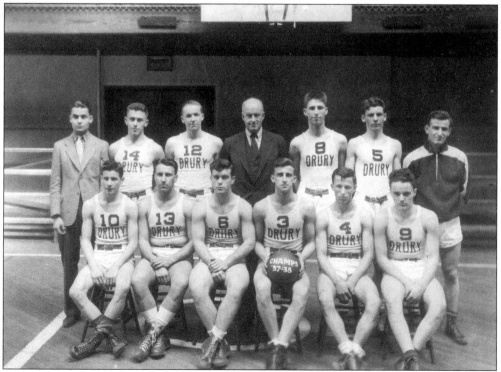

THE BOYS' BASKETBALL TEAM. This is the 1937–1938 championship boys' basketball team of Drury High School.

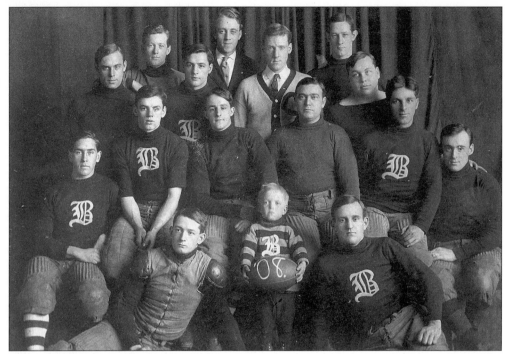

THE 1908 FOOTBALL TEAM. The Braytonville School football team of 1908 poses here. The tiny mascot is Walter "Bluebell" Southgate.

MAIN STREET, 1889. This is the upper part of Main Street, where Ashland Street has not yet been cut through to Summer Street. Main Street at the turn of the century was always a hub of activity. Citizen gatherings were a common sight.

HOME SWEET HOME. The living quarters of North Adams residents always spanned the entire spectrum. These two photographs show the extremes. The photograph above shows the mud huts of the workers for the Mount Williams Reservoir in 1914. The image below shows a typical affluent North Adams Victorian home from the same period. Regardless of economic differences, North Adams citizens have always learned to live together in harmony.

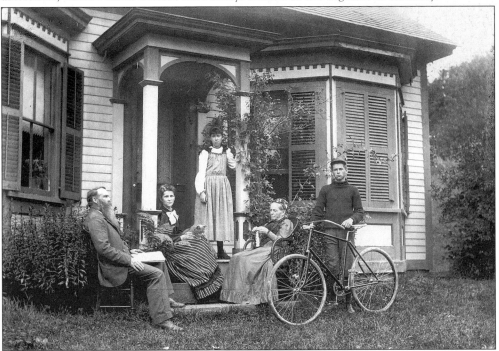

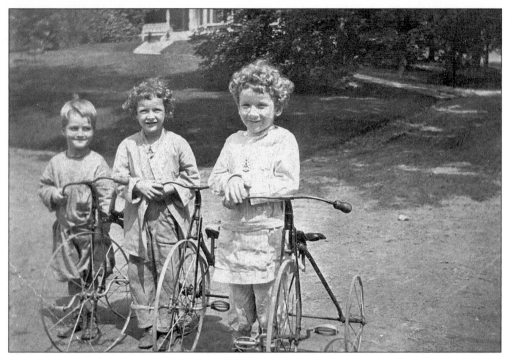

TRICYCLES. If you grew up in North Adams, your childhood was filled with warm memories, which inevitably included a bicycle—or in this case, a tricycle. The hilly terrain in many of the city's areas meant a challenge in endurance, but it kept the children in shape.

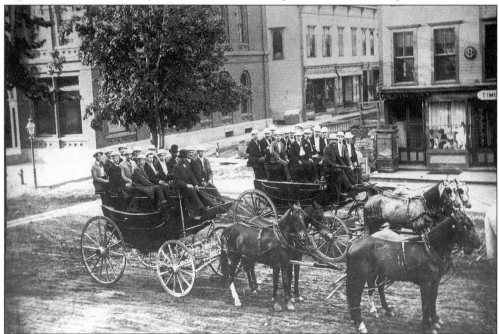

ALL THE WORLD'S A STAGE! Shown at the corner of Main and Bank Streets is a local German choir. The group started out at six in the morning on Sunday, August 1, 1889, on a trip to Pontoosac Lake in Pittsfield.

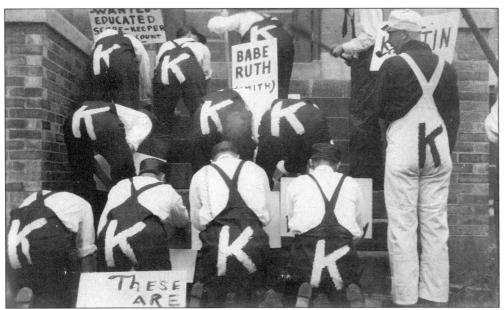

THE KIWANIS CLUB, 1920s. Men's clubs were always popular in North Adams. These comical photographs show the antics of the Kiwanis Club.

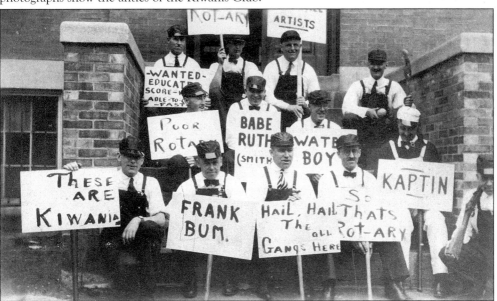

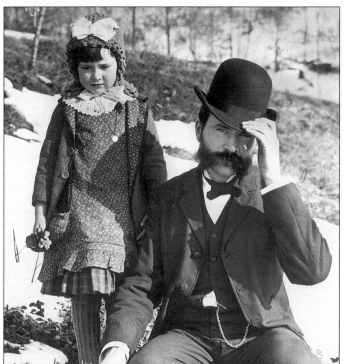

DAD AND DAUGHTER. This man is spending a Sunday afternoon in North Adams with his daughter in the late 1800s.

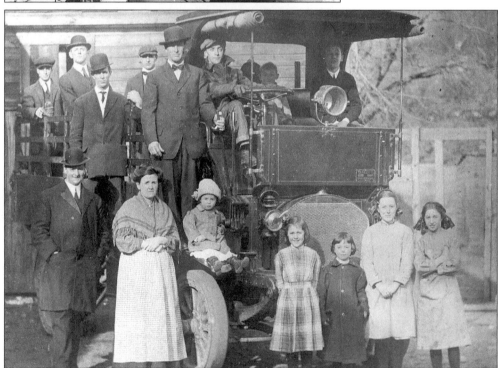

THE FIRST GASOLINE TRUCK. This 1912 photograph is labeled "the first gasoline truck in North Adams." Trucks and cars dramatically changed the way people conducted their business and spent their leisure time.

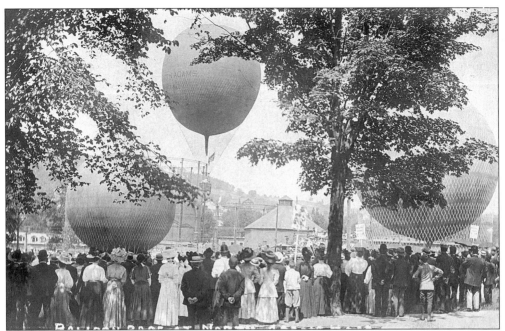

UP, UP, AND AWAY! In the early 1900s, the city sprung into prominence as a hot air ballooning center, as the gas manufactured here was well suited to aerial navigation. Many of the world's famous aeronauts made flights from North Adams. The city became a starting place for point-to-point races.

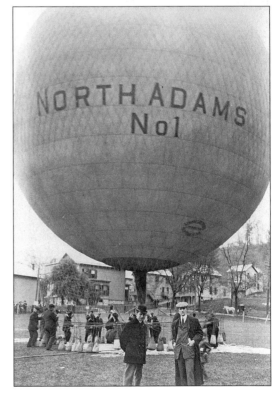

"WE'RE NO. 1!" North Adams became a ballooning center by accident—namely, the failure of a gas company in another city to furnish the required quality of gas for an ascension. By 1908, therefore, North Adams jumped to the forefront as the city from which the greatest number of ascensions were made.

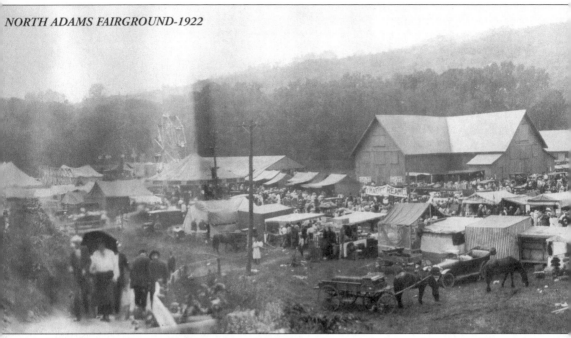

THE NORTH ADAMS FAIRGROUND, 1922. The fairground—located between West Main Street and the river, off Goodrich Street behind Fairgrounds Avenue—was home to carnivals,

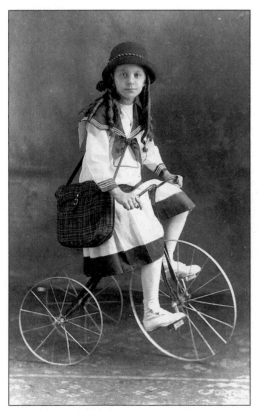

ALL DRESSED UP. This *c.* 1900 postcard gives us a taste of the clothing and transportation for a young girl who seems ready for a Sunday afternoon ride.

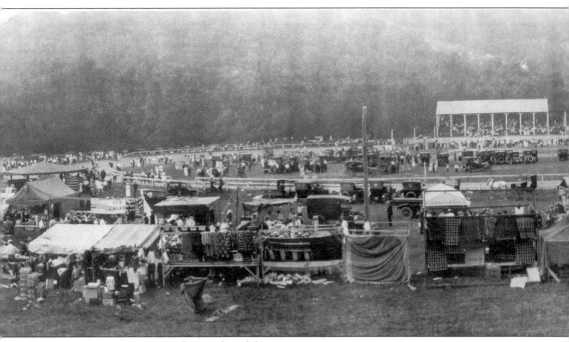

horse racing, and country and agricultural fairs.

A Favorite Doll. Maria Rose Bombardier, age four, owned two dolls—one for playing and one for posing, as in this 1912 photograph.

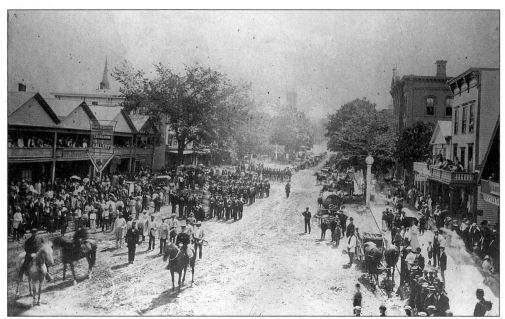

MARCH ON! This *c.* 1860s view of a Memorial Day pageant looks east on Main Street.

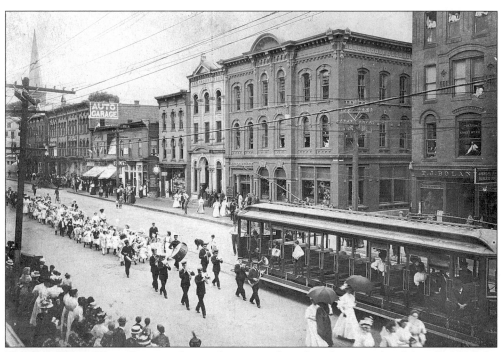

THE OLD HOME WEEK PARADE. It was always a perfect place for a parade—Main Street and a sunny day. This Old Home Week parade took place in 1910.

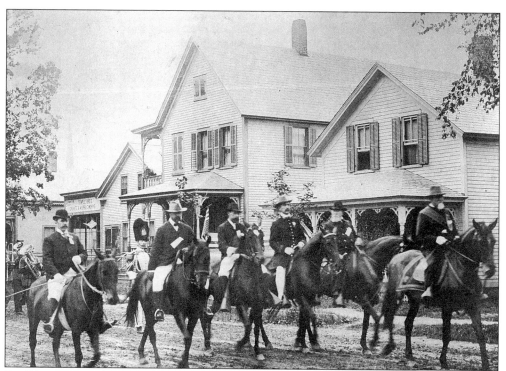

SIX HORSEMEN. This undated photograph shows six horsemen leading a parade. Behind them is a glimpse of a band. Since the street is not paved, this is probably a late-1800s parade.

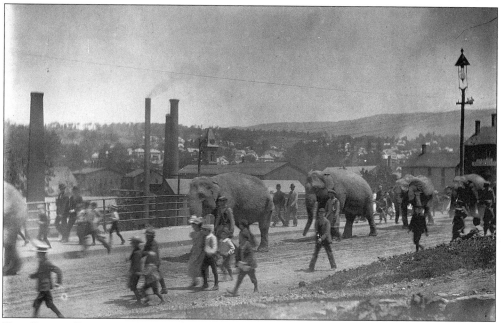

THE CIRCUS COMES TO TOWN. The pre-circus parade of Barnum and Bailey is shown on West Main Street on the way to the fairgrounds, with elephants crossing the little tunnel. In the background is the town clock, located on the tower of the Arnold Print Works.

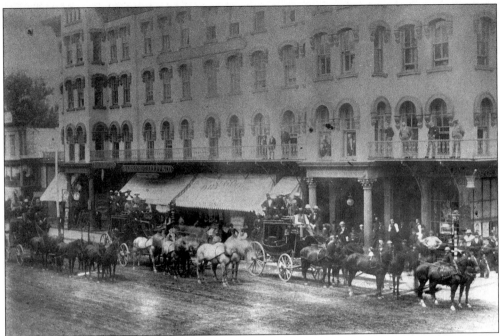

THE COACHING PARTY. This is the North Adams Coaching party starting from the Wilson House stables on May 25, 1881.

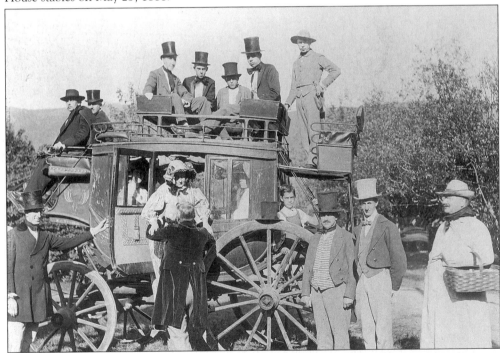

NATHANIEL HAWTHORNE'S VISIT. On June 3, 1914, North Adams residents reenacted a scene depicting Hawthorne's arrival in North Adams. Hawthorne came to the area in the summer of 1838 and stayed at the North Adams House on Main Street. He explored much of the area and described his experiences in his *American Notebooks*.

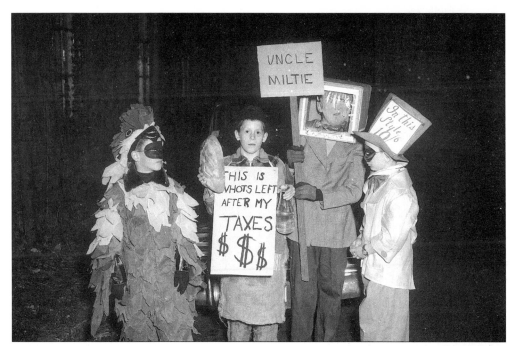

TRICK OR TREAT, 1940S STYLE. The "Uncle Miltie" costume certainly dates these trick-or-treating children. North Adams still keeps the "spirit" of a New England Halloween alive with city-organized trick or treats.

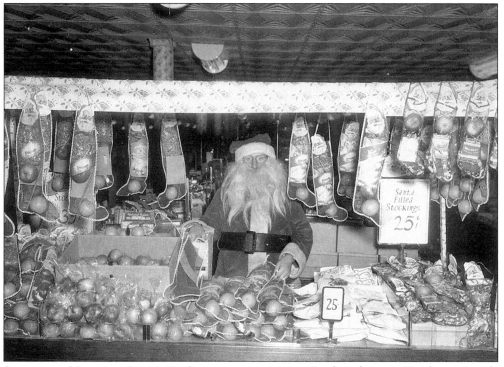

SANTA AT NEWBERRY'S, 1949. Santa pays a visit to North Adams at Newberry's candy counter on Main Street.

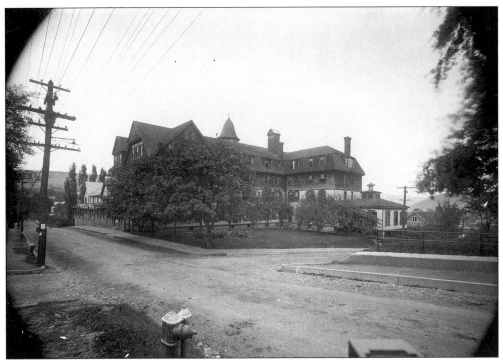

THE BERKSHIRE HILLS SANATORIUM, 1919. The Berkshire Hills Sanatorium gave North Adams the distinction of having the world's largest and most complete institution for the treatment of those suffering from any special form of disease.

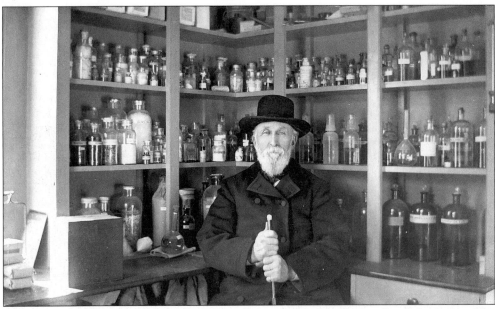

THE SANATORIUM LABORATORY. Thomas Pearson is shown in his laboratory. The sanatorium's elaborate and thorough equipment, as well as its humane and scientific work for treating those suffering from disease, was the goal of founder Wallace Brown.

THE NORTH ADAMS HOSPITAL, 1885. The story of the North Adams Hospital, opened in 1885, is a story of constantly increasing and uninterrupted work for the welfare of the community and service for good. In 1882, a terrible collision in the railroad yard alerted the citizens of North Adams to its lack of facilities to care for the wounded and dying. The event prompted the town to take steps toward establishing a hospital. This photograph shows the original hospital, which opened with 12 patient beds and cared for 34 people during its first year of operation in 1885.

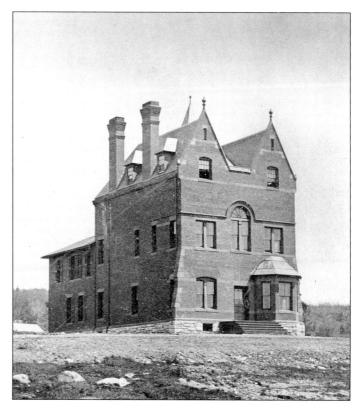

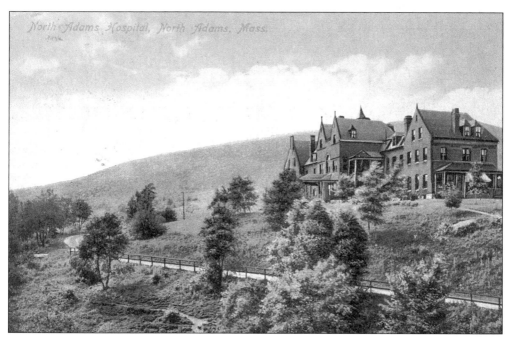

THE NORTH ADAMS HOSPITAL, 1910. This postcard, mailed in 1910, shows the progress of the hospital building and the beautiful, serene landscape on a hill overlooking the city.

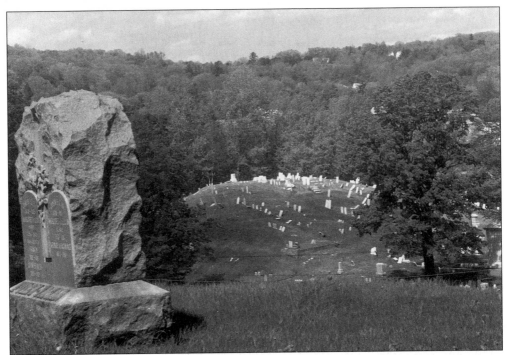

HILL SIDE CEMETERY. Dating to 1798, Hill Side is the city's second oldest existing cemetery. Many important citizens are interred there, and the cemetery contains many beautiful monuments. It is unique in that a main highway (Route 2) runs through it. This photograph shows one of many inspiring views from its hilly terrain. (Photograph by Robert Campanile.)

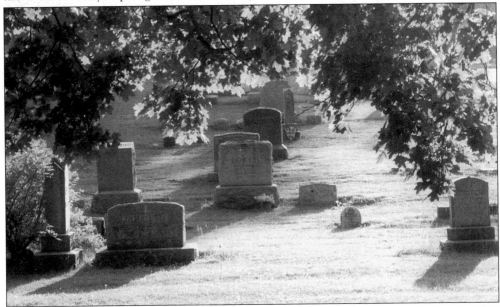

SOUTH VIEW CEMETERY. On the opposite side of the city from Hill Side, this cemetery has monuments dating to the early 1800s. Its atmosphere is serene and quiet. On any given morning or evening, one can find citizens walking or jogging through the grounds, as the peaceful setting surrounded by the mountains creates a calming effect. (Photograph by Robert Campanile.)

Six

ONE CITY, UNDER GOD

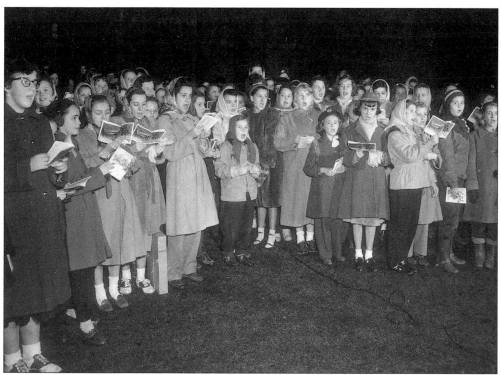

ONE VOICE. This 1950s photograph shows North Adams citizens raising their voices together for Christmas caroling. North Adams has always been proud of its religious convictions and places of worship. A strong religious dedication has contributed to the high degree of moral and mental development among its citizens. An early book reads, "It is stated that the early settlers held meetings more frequently and exhibited a deeper religious zeal when their provisions became short and their garments ragged."

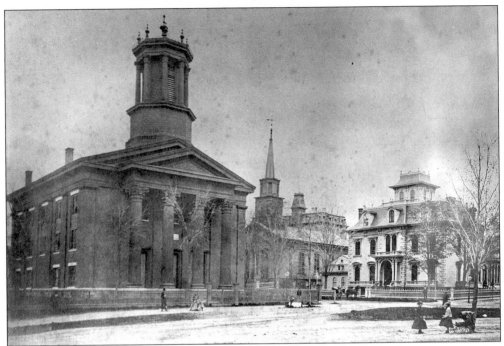

THE OLD BAPTIST CHURCH. In 1808, Elder Charles B. Keyes organized a Baptist congregation with a membership of 22 people. Because of the continued growth of the town and the church, a large building was erected in 1848. In May 1879, this church was so badly burned that its ruins were removed and the present church was erected. It is located on Monument Square at the east end of Main Street.

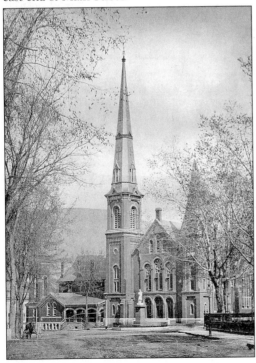

THE PRESENT BAPTIST CHURCH. The splendid edifice boasts the tallest steeple in North Adams (191 feet) and the second tallest in Massachusetts. The old meetinghouse still stands behind the church on North Church Street. The bell is still rung every Sunday by hand. The church is located at the foot of what was once known as Church Hill.

THE OLD METHODIST CHURCH. In 1823, the Methodist Church Society was organized here. In 1824, a lot was purchased on Center Street for $30. In 1842, the present site on Church Street and Monument Square was procured. This old church, built in 1873, burned down in 1927.

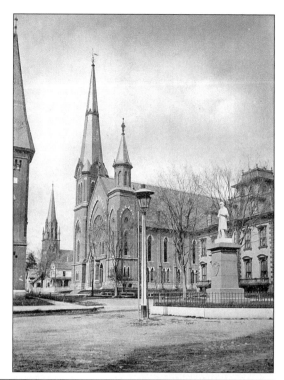

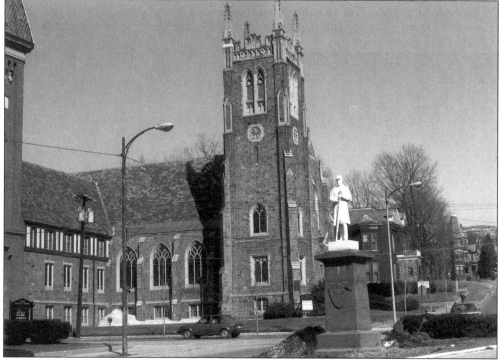

THE METHODIST CHURCH. This building replaced the old church in 1929. The granite steps are from the original church. The church boasts one of the finest organs in the area; it is used in a highly popular summer organ recital series. This is a fine example of the Neo-Gothic style.

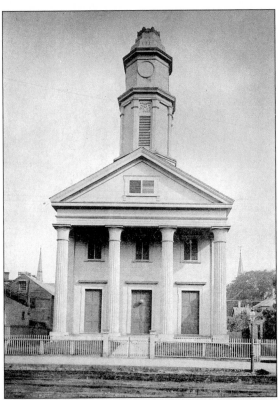

THE OLD UNIVERSALIST CHURCH. The Universalist congregation was organized in 1842. In 1851, the church purchased the lot on State Street. This building cost $7,100 and seated 500 people.

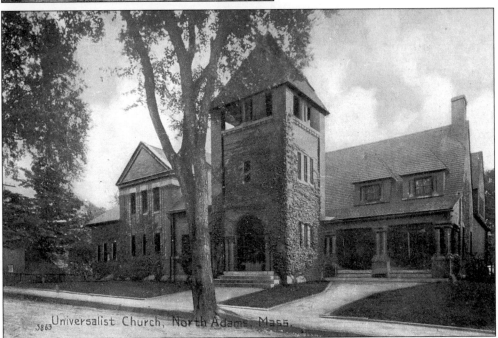

THE UNIVERSALIST CHURCH. One of the more interestingly designed churches is located on Summer Street. Built in 1893, it is constructed of thin roman brick with classical and terracotta details. Today, this church is unoccupied and waiting for an imaginative use.

THE ST. FRANCIS OF ASSISI CHURCH. Early Irish settlers established the St. Francis of Assisi parish in 1863. The church shown here was built in 1869, the largest church in New England at the time.

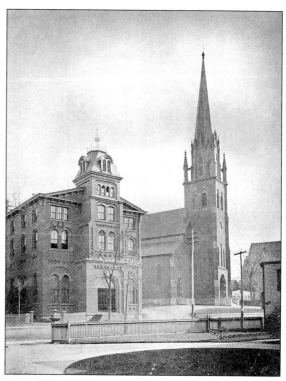

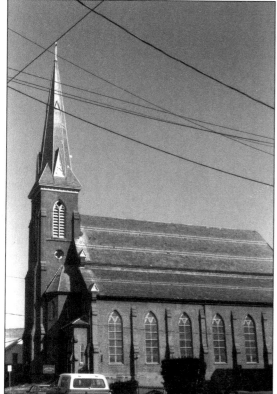

NOTRE DAME DU SACRE COEUR. In 1871, Fr. Charles Crevier arrived in North Adams to form the Notre Dame parish for the city's French Canadian residents. This allowed them to have Mass said in their native tongue. This French Gothic church was built in 1875.

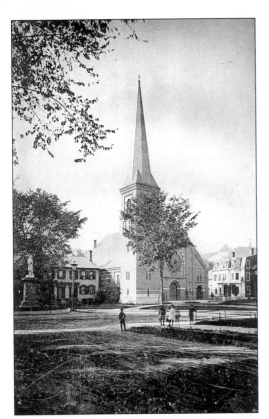

THE CONGREGATIONAL CHURCH. The Congregational parish was founded in 1827. This church was built in 1865 and is an excellent example of the Italian Romanesque style. The tower is 150 feet high, and the original stained-glass windows date to 1865. Most of its stained-glass windows were done by Tiffany.

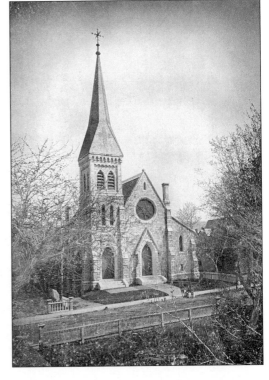

ST. JOHN'S EPISCOPAL CHURCH. The St. John's parish was organized in 1855 by two Williams College students. The building shown here replaced a small church in 1867. The stone used for this Rustic Gothic style was quarried from Witt's Ledge. It contains a rare tubular bell carillon from 1925. Three of its stained-glass windows were done by Tiffany.

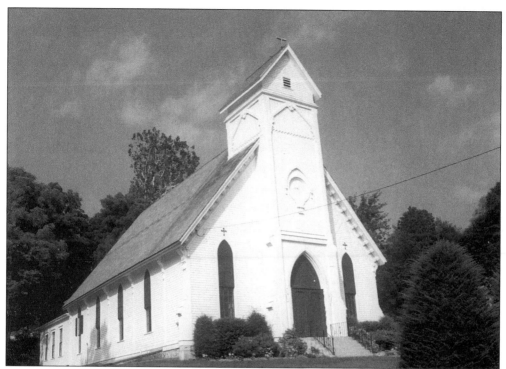

A Blackinton Church. The church, located in Blackinton, was organized by Rev. John Alden in 1843 with 20 members. The church building was erected in 1871 by Sanford Blackinton and was donated to the village. This contemporary photograph shows the church without its original steeple. (Photograph by Robert Campanile.)

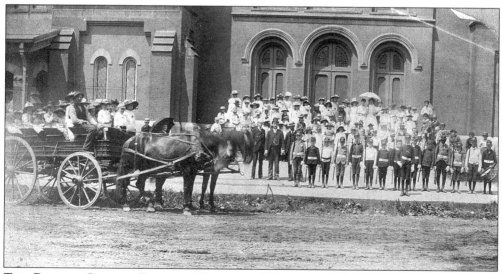

The Baptist Church Brigade. This turn-of-the-century photograph shows the Baptist church brigade about to embark on a Sunday picnic to Kemp Park.

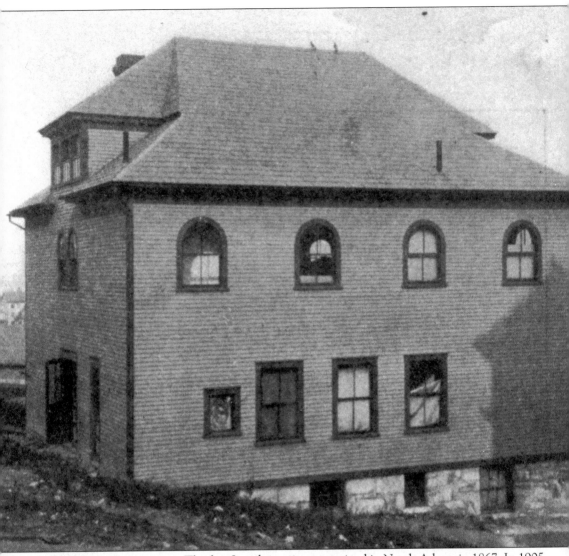

THE FIRST SYNAGOGUE. The first Jewish immigrants arrived in North Adams in 1867. In 1905, a second group formed a congregation. Pictured is the first synagogue, which was built in 1894 on Francis Street and was called the House of Israel. (Courtesy of Lillian Shapiro Glickman.)

Seven

A CALL TO ARMS

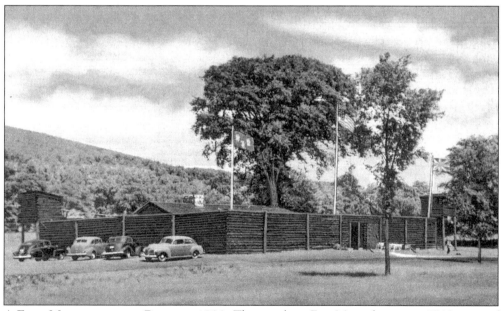

A FORT MASSACHUSETTS REPLICA, 1933. The attack on Fort Massachusetts in 1746 is one of the most dramatic historical events in the story of North Adams. It took place during one of the many wars between the French and English. On August 19, 1746, the fort was attacked by 900 French and Native Americans. Less than two dozen British soldiers and a handful of civilians defended the fort for over 28 hours before surrendering. The French then burned the fort and took the captives to Canada.

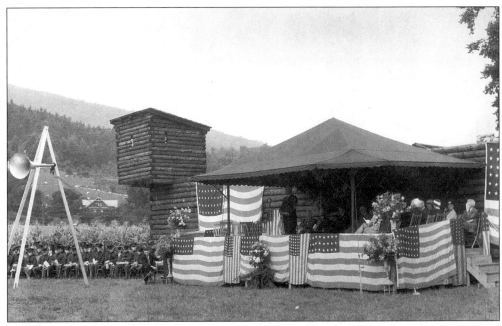

THE DEDICATION OF FORT MASSACHUSETTS. The site of the fort, located on the western part of the city, was acquired in 1896 by the Fort Massachusetts Historical Society. A replica of the fort was built on the site and was dedicated on August 19, 1933, as shown in this photograph.

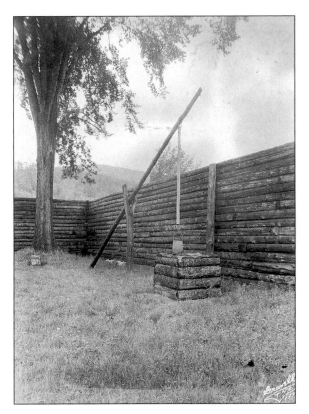

THE INTERIOR YARD OF FORT MASSACHUSETTS. The replica served as the home of the historical society until the 1940s, when a lack of funds forced the society to close. The building then served as a restaurant before being torn down in the 1960s urban renewal fever.

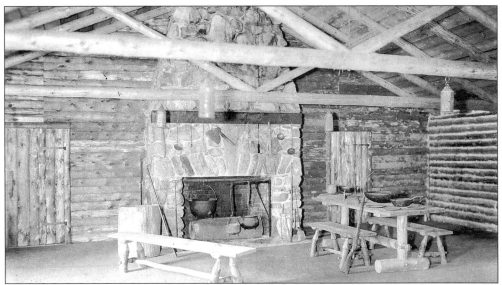

THE FORT MASSACHUSETTS BARRACKS ROOM. This is a replica of the barracks room inside one of the fort's buildings. When the fort was torn down, the chimney shown here was left standing. The chimney can be seen today at the end of the Price Chopper parking lot, located on State Road (Route 2).

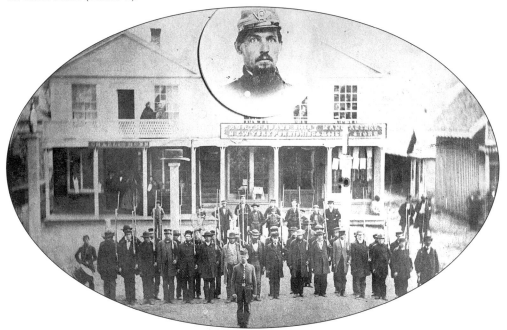

THE JOHNSON GREYS. In September 2, 1855, North Adams had a military company known as the Greylock Infantry. The company formed the rallying point for the region's young men who responded to the call to arms during the Civil War. On April 18, 1861, a recruiting office opened and, in a week, 83 names were on the rolls. The company called themselves the Johnson Greys in honor of Sylvander Johnson, chairman of the town committee. Camp Johnson was set up on the present grounds of the Massachusetts Museum of Contemporary Art, where a plaque commemorates the unit.

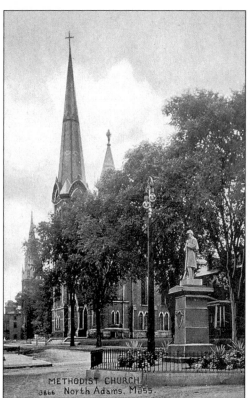

CIVIL WAR MONUMENT SQUARE. The soldiers' monument stands at the head of Main Street on the common. The monument, dedicated on July 4, 1878, bears the inscription "Presented to the town of North Adams by the Ladies' Soldiers' Aid Society." This group helped support all the men who fought in the Civil War.

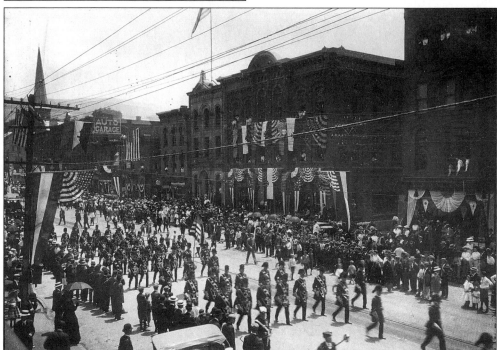

INDEPENDENCE DAY, 1910. In the early days, the Independence Day parade was a huge affair. This photograph shows Main Street caught up the excitement of the day.

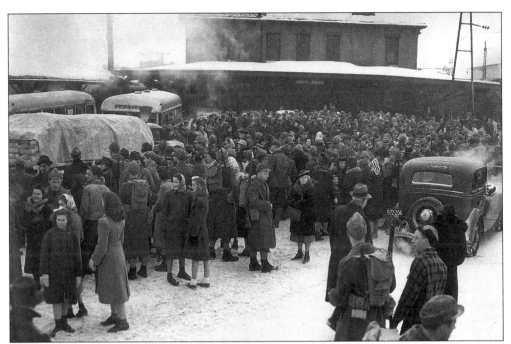

OFF TO WAR. This scene during World War II represents one of the hardest parts of the war for the city's residents. Saying goodbye to the men at the railroad station as they left for training added yet another dimension to the history of this site.

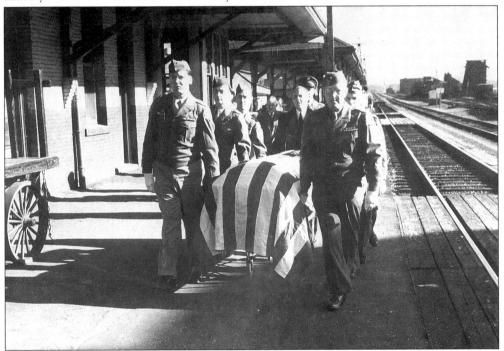

A SAD RETURN. North Adams has a long list of heroes who gave their lives through every war this country has been involved in. This World War II photograph could be any war and any time from the French and Indian Wars to the Gulf War.

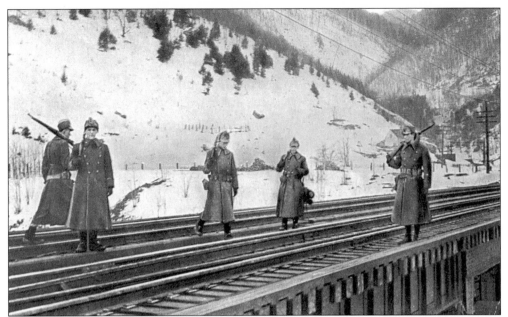

GUARD DUTY. This photograph shows American troops guarding the railroad bridge and Hoosac Tunnel during World War II. This precaution was not limited to North Adams, as most railroad bridges, canals, and similar places throughout the country were guarded during the war.

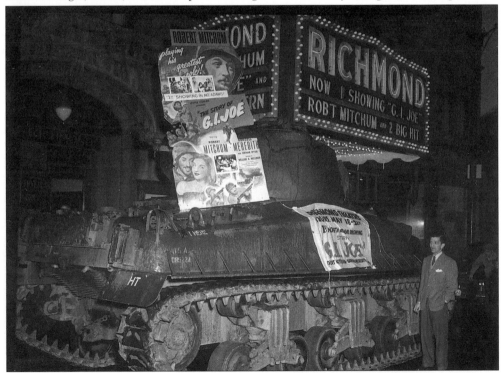

WAR ON FILM. This image illustrates the extent to which advertising for the 1950 movie *G.I. Joe* was taken by the Richmond Theater on Main Street. The tank was real, even if the movie was not.

Eight
ARCHITECTURAL
TEXTBOOK

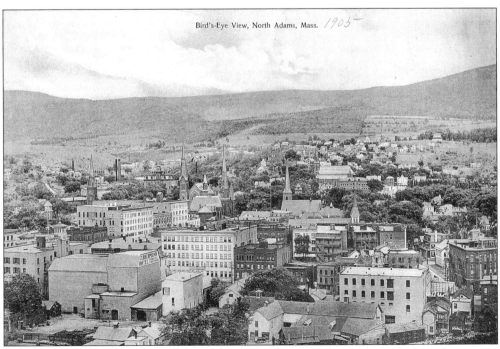

Bird's-Eye View, North Adams, Mass. *1905*

A BIRD'S-EYE VIEW. The city's unusual site in the valley produced narrow and winding streets on steep hills, with a string of factories and mills along the river. The scope of architectural styles from every period of its history took advantage of this diverse landscape, creating a scene of verandas, rooftops, steeples, and high-reaching Victorian towers.

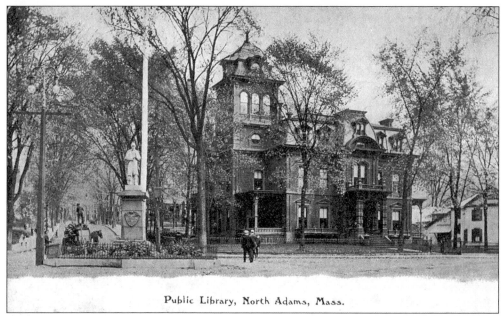

Public Library, North Adams, Mass.

THE BLACKINTON RESIDENCE, LIBRARY. The Blackinton Mansion (now the public library) is the most outstanding example of the Second Empire style. The tower is dominating on Main Street. Brick with brownstone trim and ornamented with a mansard roof and neoclassical details, the mansion was designed by Marcus Cummings of Troy, New York. Built in 1869, it was given to the city as the public library in 1898.

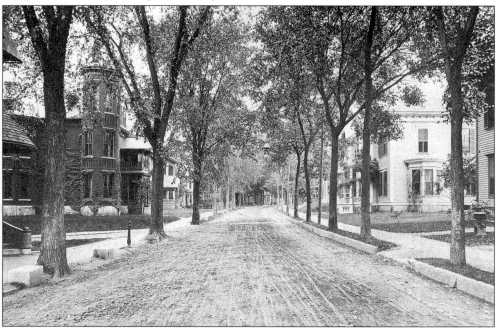

CHURCH STREET, 1890s. Church Street has been described as an outstanding collection of Victorian residential architecture. Most of the homes on this street were built between 1865 and 1900 for the city's economic and political leaders. The street includes at least one outstanding example of every architectural style.

102

THE RODMAN WELLS HOUSE, 1850S. Distinctive for its style is this residence from the 1850s. It now stands on Ashland Street after being moved from Main Street in 1874. It is the only surviving Greek Revival–style structure in North Adams with a columned portico. The highly Greek-designed tower on top has been removed.

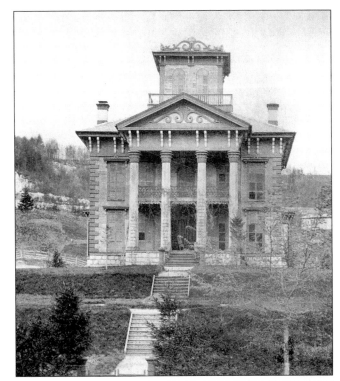

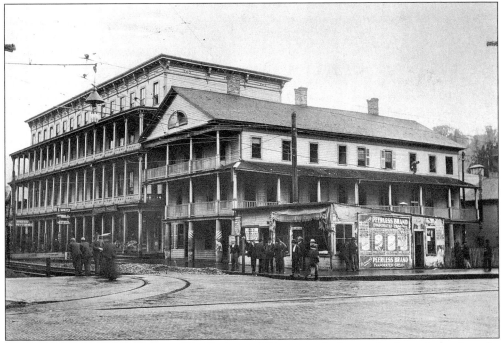

THE RICHMOND HOUSE, 1890S. The Richmond House (with the porches) was located on the corner of State and Main Streets. It burned in 1922. In this view, trolley tracks can be seen going around the corner down State Street. The building next to the Richmond House is the first Richmond Hotel.

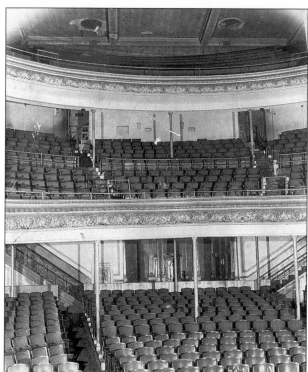

THE RICHMOND THEATER. Like the city of North Adams, the Richmond Theater suffered its ups and downs. It opened in 1900 and was very successful through the 1920s. It survived the effects of fire and flood in 1927. In 1921, it was enlarged to seat 1,700 people and became the largest theater in western Massachusetts at the time. The Richmond Theater closed in May 1950 and was eventually demolished during urban renewal.

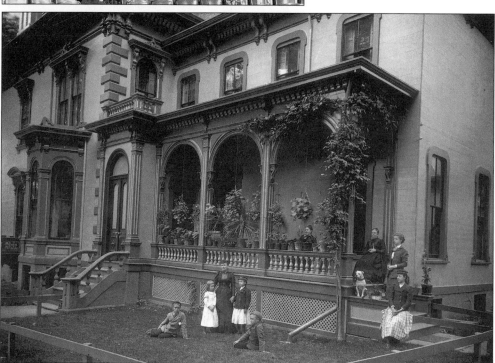

THE AMASA RICHARDSON HOUSE, C. 1880. The Richardson family poses in front of their beautiful Italianate-style home, located on corner of North Church and East Main Streets. The first floor was used as a public library before moving into the Blackinton Mansion.

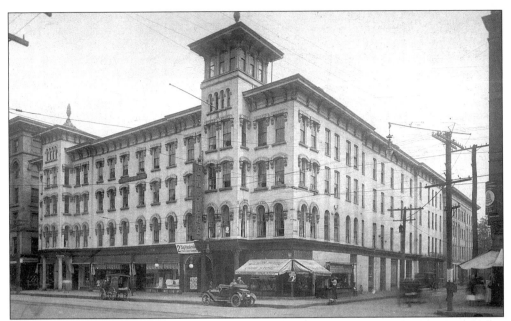

THE WILSON HOUSE, 1900. The Wilson House grand hotel was built in 1866. Theodore Roosevelt spoke in the theater in 1912. On July 2, 1912, it was consumed by fire. The theater was rebuilt and renamed the Empire.

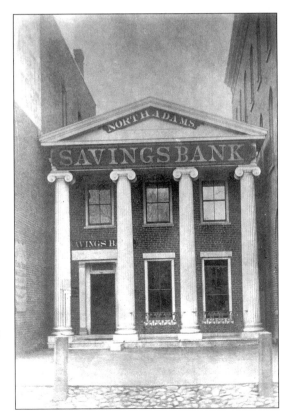

THE NORTH ADAMS SAVINGS BANK. This bank was opened in the 1840s. The Greek Revival–style pillared building on Main Street was demolished in 1884. The North Adams Savings Bank eventually merged with the Hoosac Savings Bank.

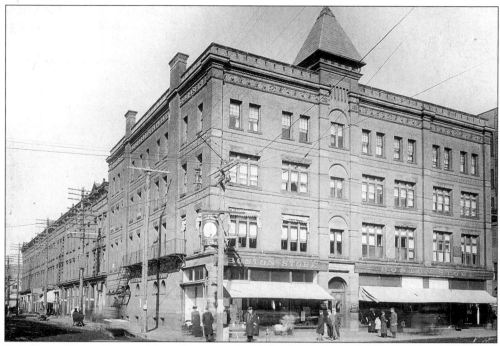

THE BLACKINTON BLOCK, MAIN STREET, 1914. The Romanesque brick structure was built for Sanford Blackinton. It is distinguished by a fortress-style roof parapet. The mock tower no longer remains.

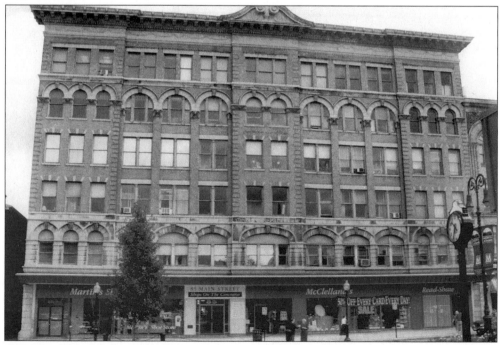

THE NEW KIMBALL BUILDING, MAIN STREET. The Kimball Building was a turn-of-the-century skyscraper. It was the first building in North Adams to use steel pilings in its design, as it was built over quicksand pits. (Photograph by Robert Campanile.)

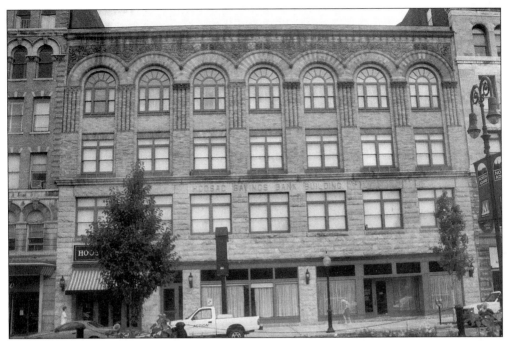

THE HOOSAC SAVINGS BANK BUILDING, MAIN STREET. Designed with terra-cotta detailing, this turn-of-the-century structure has ghoulish faces looking down on Main Street from the columns on the fourth floor. (Photograph by Robert Campanile.)

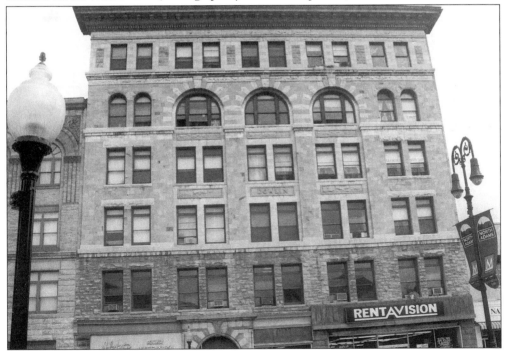

THE DOWLIN BLOCK, MAIN STREET. This Italian Renaissance skyscraper, with its granite face, was designed by Edwin Barlow, who lived in North Adams. His other great achievement is the facade of the famous New York Public Library. (Photograph by Robert Campanile.)

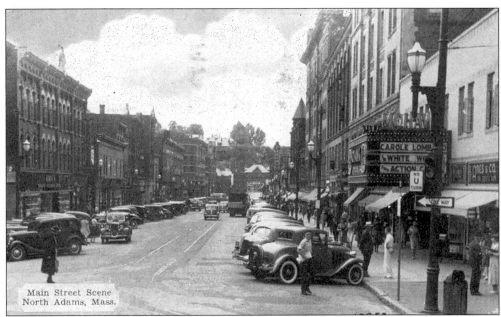

THE MOHAWK THEATER, 1940. The Main Street movie theater (right) was one of the few commercial buildings constructed during the Great Depression era. Today, it is in the process of being revitalized.

THE FLAT IRON BUILDING, EAGLE STREET. One of the most unusual commercial buildings on Eagle Street is the Flat Iron Building. The shape almost makes the Italianate-style details of secondary interest. This photograph shows it before the paved streets. It was built in 1854.

THE CHURCH STREET HOUSE. This house is noted for its elaborately patterned slate roof and lacy wood trim. Notice its kick roof shape (concave). It was built in 1872 for Dr. Henry Millard, who was a prison doctor during the Civil War.

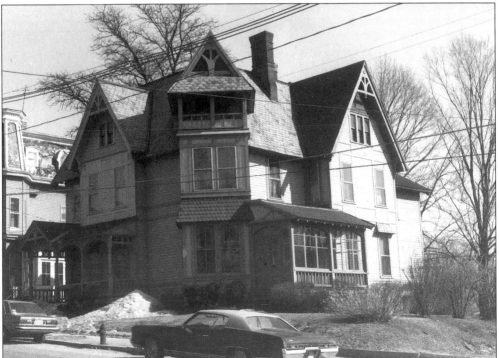

THE CUTTING HOUSE. The Victorian styles were many and varied. Built in 1881, this house shows some of the classic features, with towers, details, and offset sides and shapes. It is located on East Main Street behind the public library.

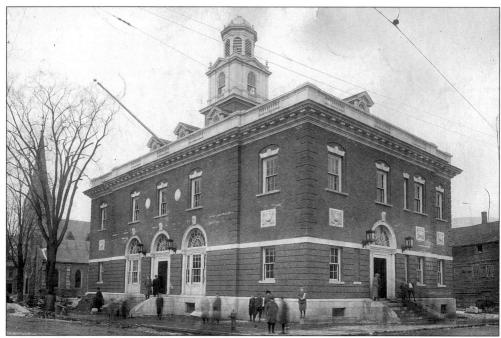

THE POST OFFICE, 1910. An important example of the Colonial Revival style in a commercial building is the post office, built in 1910 at the corner of Summer and Ashland Streets. It was the work of James Taylor, supervising architect of the U.S. Department of Treasury.

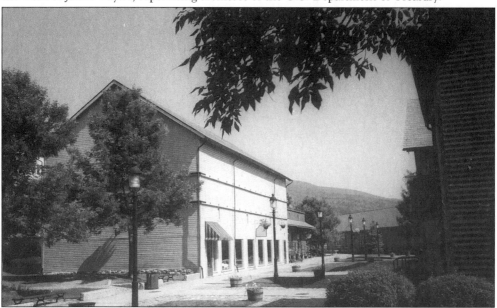

FROM OLD TO NEW. The former 1800s freight yard was converted into the Western Gateway Heritage State Park in the 1980s. Included in the restoration of the buildings are a Hoosac Tunnel Visitor's Center, restaurant, gift shop, artist galley, and the new North Adams Museum of History and Science, as depicted in this photograph. The museum, run by the North Adams Historical Society, is housed in the former coal storage building. The trains still rumble past the park, adding to the nostalgic flavor. (Photograph by Robert Campanile.)

Nine

ALL ABOARD!

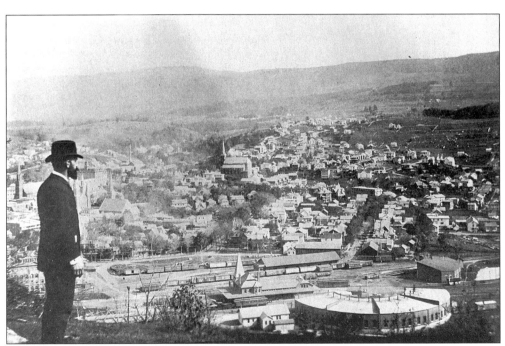

A BIRD'S-EYE VIEW OF THE DEPOT AND YARD, 1900. The first railroad came to the town in 1843 as the Pittsfield and North Adams Railroad. Eventually, with the Hoosac Tunnel providing direct access to the east, North Adams became a railway center to match its industrial and manufacturing might. This view, taken from Witt's Ledge, shows the extent that the railroad had grown by 1900. The famous Victorian depot station and roundhouse are visible.

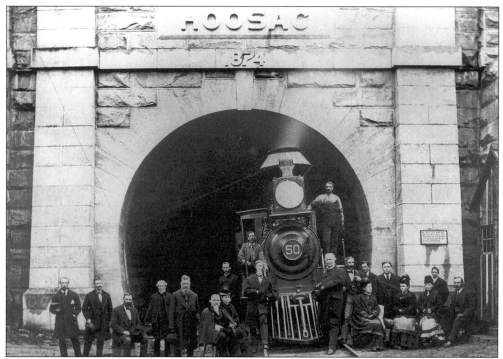

THE HOOSAC TUNNEL, WEST PORTAL, 1876. This early train moves through, with the railroad commissioners posing between rails. Around 1820, it was proposed that a canal be built over or through the mountains to the east of the city. Eventually, a tunnel was seen as a more practical solution. The great adventure began in 1851. The tunnel took 25 years to build and cost almost 200 lives.

RAILROAD WORKERS. "I've been working on the railroad." Always a big business in the early days of North Adams, the railroad allowed the city's huge industrial might to be transported across the nation, helping to give the city its prosperity.

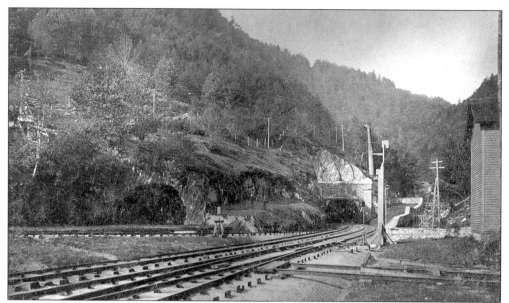

THE HOOSAC TUNNEL, EAST PORTAL, 1890. The tunnel was considered an engineering feat that achieved a precision beyond what was thought possible. When the tunnel workers met in the middle of the four-and-three-quarter-mile stretch, both sides were aligned within fractions of an inch. Many tools that attempted to drill through the mountain did not work. The first use of nitroglycerin finally helped achieve the needed results.

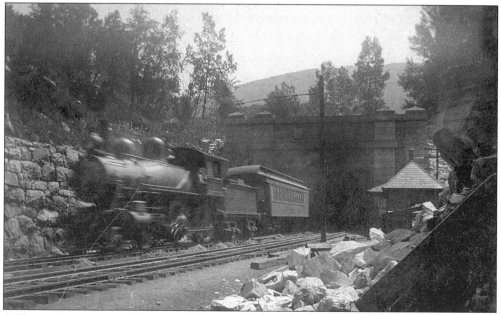

A TRAIN EXITING THE TUNNEL. A Boston & Maine locomotive on the Fitchburg line blows its whistle as it exists the tunnel. The first passage of train cars through the tunnel occurred on February 9, 1875. The first freight was on April 5, 1875, and consisted of 22 cars of grain. The tunnel, however, was not declared ready for business until July 1, 1876. In round numbers, the tunnel is 25,031 feet long, 20 feet high, and 425 feet wide. Some 1.9 million tons of rock were excavated, and 20 million bricks were used in its construction.

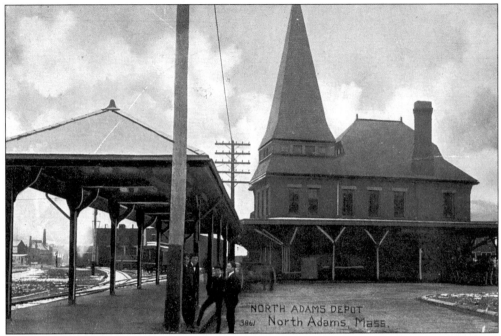

THE RAIL YARD, 1900. This was the Boston & Maine side of the North Adams railroad depot. The far side was the Boston & Albany section. The Victorian-style station dominated the rail yard and stood as a beacon for people who decided to take a chance on a new life in North Adams.

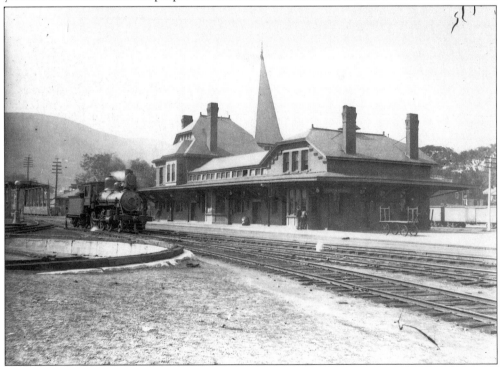

A DEPOT AND TRAIN. Captured in this beautiful photograph is the atmosphere of the age of steam engines and railroad depots. The switching engine on the left is called a "hog."

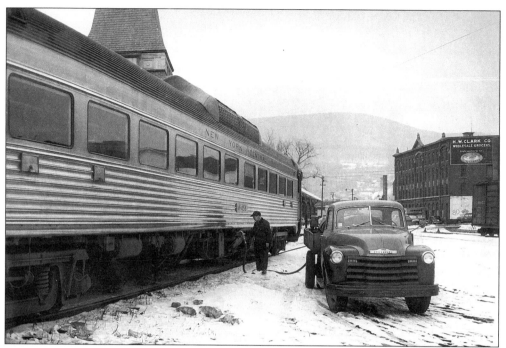

THE NEW YORK CENTRAL RAILROAD. This image is probably from the 1940s, a time when North Adams was accessible from Grand Central Station in New York City. The New York Central "Bud-Liner" run is shown being serviced in the rail yard.

THE SWITCHING TOWER. Most likely built c. 1910 at the time of electrification, the West Portal Tower controlled the crossovers in front of it and the switch to the eastbound track. It also controlled signaling in the tunnel. The man in this tower would be the train director and would earn more money than the man in the east tower.

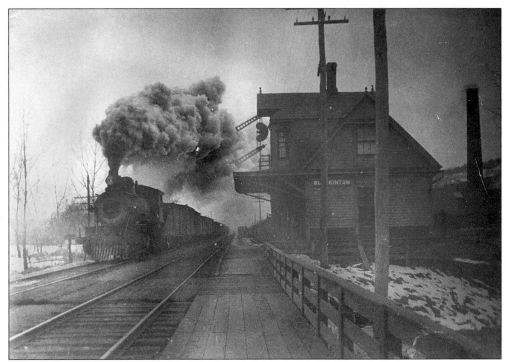

BLACKINTON STATION. North Adams had a station in the Blackinton section of the city. This early-1900s photograph shows a steamer pulling into the station.

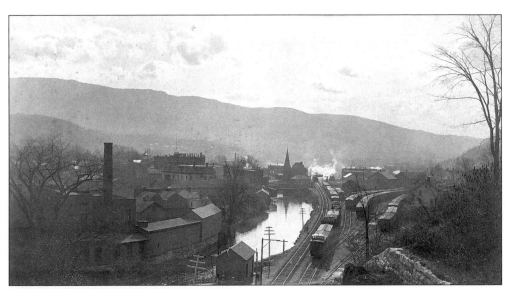

THE NORTH ADAMS RAILROAD YARD. This image shows a beautiful portrait of the rail yard with the mountains in the background.

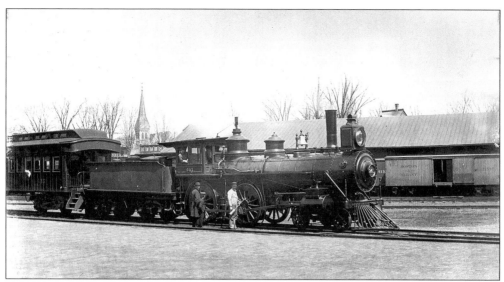

A Boston & Albany Engine. A Boston & Albany train is shown getting ready for a run to New York City. It made two or three runs a day and took five or six hours to make the trip. The steeple in the background on the left is St. John's Episcopal Church.

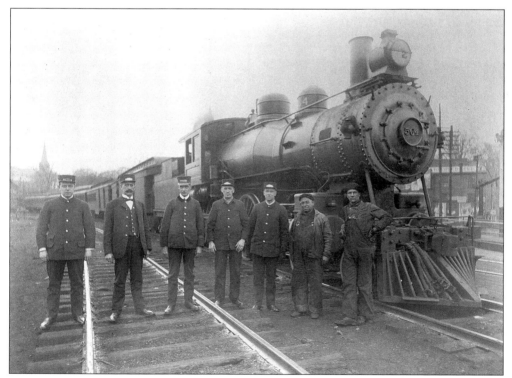

A Train Engine. A magnificent steam locomotive is always an imposing and exciting sight. The second man from the right is Sewell Ainsworth, who was the engineer on the first freight train through the Hoosac Tunnel in 1876.

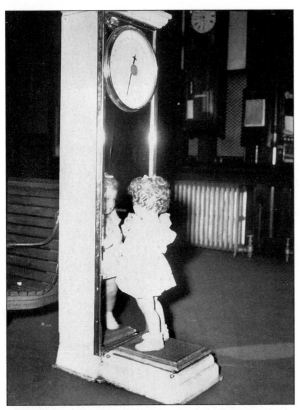

A GIRL AND A STATION. This charming photograph shows the interior of the famous Victorian Union Station of North Adams. It contrasts beautifully with the innocence of a curly haired child and the masculine design and atmosphere of railroading in the old days. On the right is the ever popular Chicklets gum machine, a classic in all rail stations.

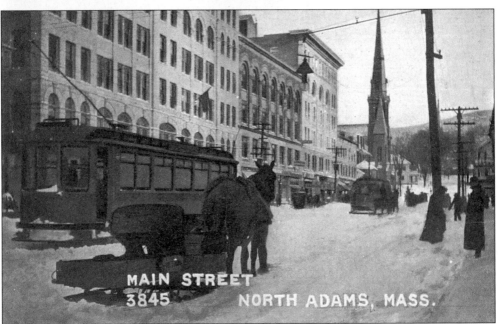

THE OTHER RAILS. The formation of the Hoosac Valley Street Railroad Company was granted in 1886. It began as a horse railroad between Adams and North Adams. In the spring of 1889, it was equipped with electric motors.

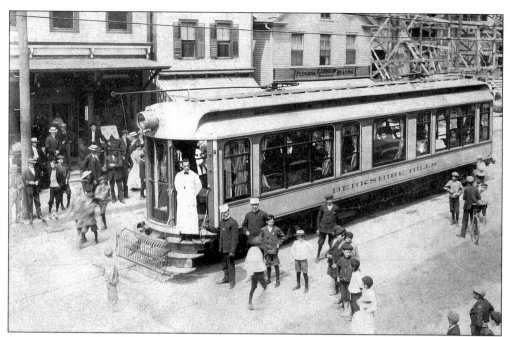

Trolleys on Main Street. Many schoolchildren rode the trolleys, which went by every hour. A person could go to Pittsfield and even to Connecticut. The other direction went to Williamstown and then up to Bennington, Vermont. (Courtesy of Doris Rennell.)

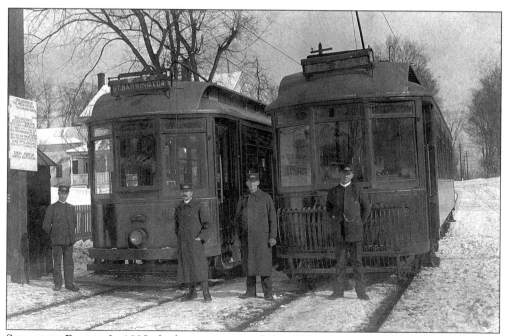

Standing Ready. In 1895, the lines were extended to Williamstown and to the Beaver section of town, making the track nearly 14 miles in length. The open trolley cars were wonderful—the sight and sound of the trolley coming and going on Main Street added a flavor never duplicated since. The trolley bell was an exciting and unique sound. (Courtesy of Doris Rennell.)

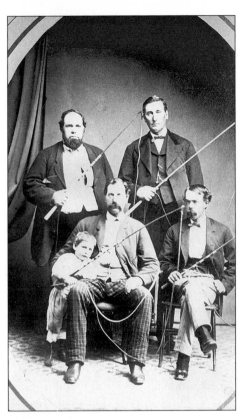

WAGONS HO! Here are four of the stalwart men who held the reins of teams that drew stagecoaches back and forth over the Hoosac mountain in the pre-tunnel days. The first stagecoach, which passed through the village for mail and passengers, was established in 1814 by a Mr. Phelps and ran once a week.

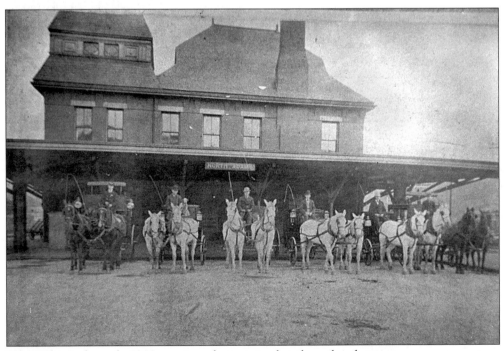

TAXI! This is the early-1900s version of a taxi stand at the railroad station.

Ten

A NATURAL HIGH

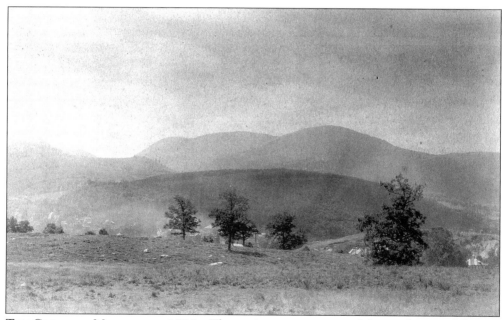

THE GREYLOCK MOUNTAINS, 1800S. The ancient environment of the northern Berkshires is one that takes us back 450 million years as the Earth's movements were creating and shifting the landscape. Shifting continental plates, roving oceans, and moving glaciers eventually carved out what is now the beautiful valleys and mountains that create the character of our environment. The name Greylock is said to be from the appearance it takes on during the frosty winter mornings, as its "locks" have an icy grey look. The range has the highest peak in all of Massachusetts at 3,491 feet.

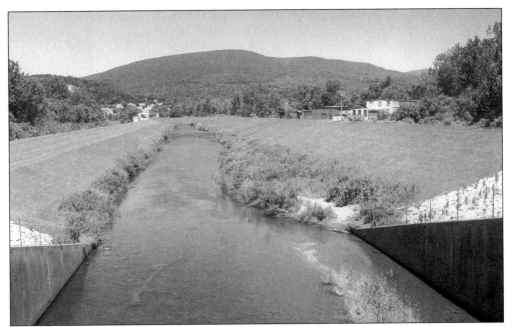

THE VERMONT MOUNTAINS. The northern part of the city is bounded by the mountains of Vermont. During the fall foliage season, these surrounding mountains bring out the best of the New England atmosphere with their vibrant colors. The Hoosic River is in the foreground. (Photograph by Robert Campanile.)

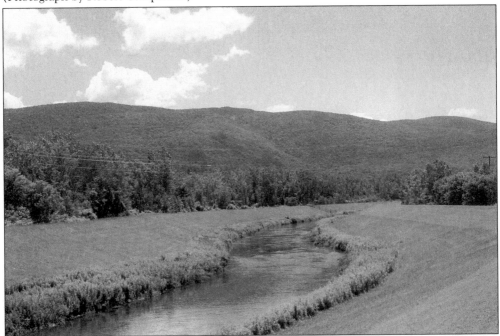

THE HOOSAC MOUNTAINS. The long Hoosac range was a barrier to the eastern part of the state until the Hoosac Tunnel was constructed in the mid-to-late 1800s. Going over the mountain on the western summit has always been an exhilarating experience and affords the best view of the city. The Hoosic River is winding in the foreground. (Photograph by Robert Campanile.)

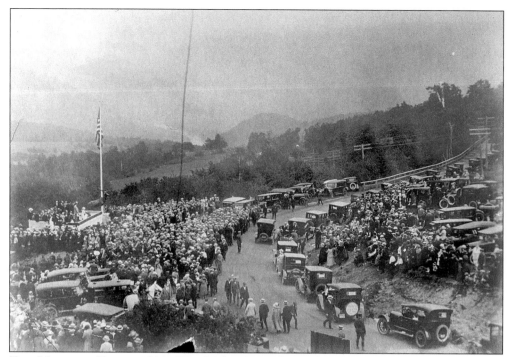

THE MOHAWK TRAIL, 1923. The Mohawk Trail was the first automobile tourist road in Massachusetts. It was christened in 1914 and has been a major attraction ever since. It is especially popular during the fall foliage season, when cars are sometimes bumper-to-bumper.

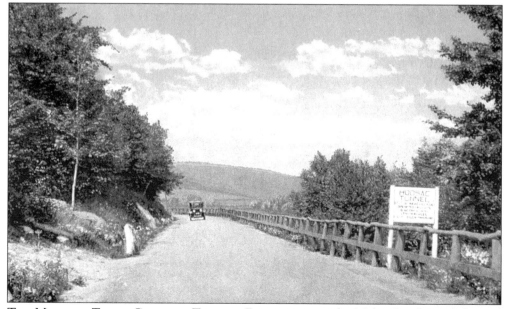

THE MOHAWK TRAIL, CROSSING TUNNEL. For many years, the Mohawk tribe trod the trail before the coming of the Dutch and English settlers. The original Native American pathway led directly through what is now our Main Street to the foot of the Hoosac Mountains.

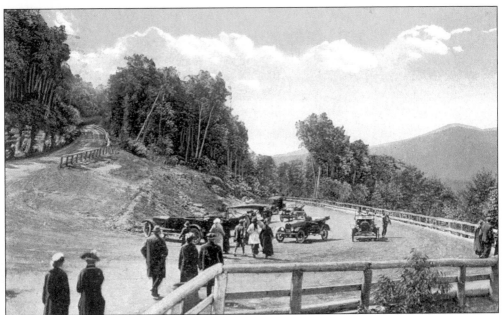

THE HAIRPIN TURN, 1920S. Part of the climb up and the drive down the Hoosac Mountains to the western summit involves negotiating the famous hairpin turn. The middle of the curve is actually in Clarksburg, so drivers enter Clarksburg for about 100 feet and then return to North Adams.

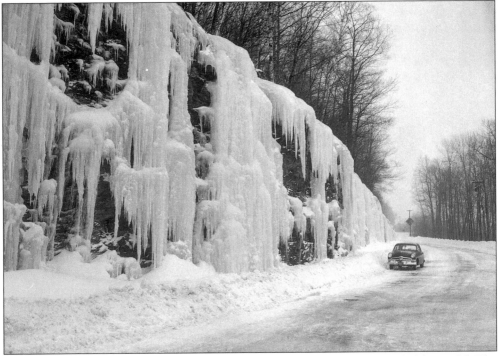

THE HAIRPIN TURN ON ICE. The winter on the turn is both dangerous and beautiful. The annual ice palace is an awesome (and distracting) site for motorists as they negotiate the winding road.

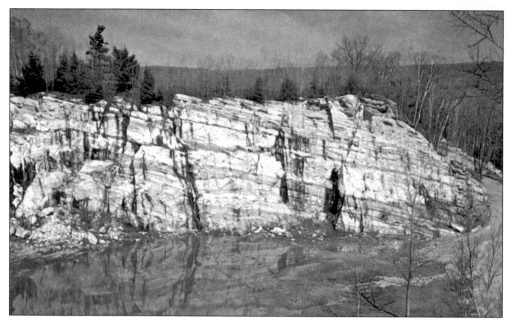

NATURAL BRIDGE. Natural Bridge was formed by meltwaters from mile-thick glaciers cutting deeper and deeper into the rock, sculpting the Hudson Brook chasm and the marble bridge that spans it. The value as building material was recognized in 1810, when quarrying began. In 1985, the Massachusetts Department of Environment purchased the property to preserve this unique geological feature in its natural condition as a state park.

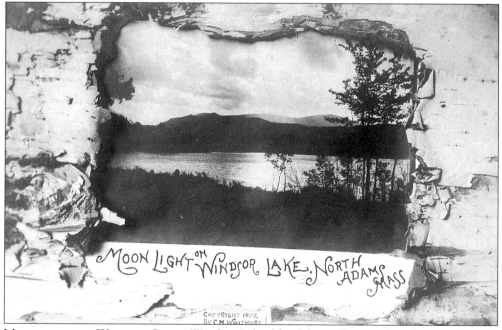

MOONLIGHT ON WINDSOR LAKE. Windsor Lake (the fish pond to residents) is a man-made lake built as a additional power source for the Windsor Print Works. The lake was later sold to the city and now offers a public beach. This interesting postcard is from 1907.

125

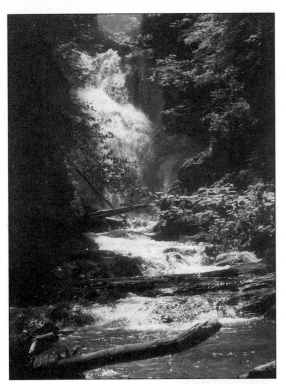

CASCADES. Hidden away in a fold of the foothills rising at the west end of the city, this area is known as "the Notch." A wild and beautiful waterfall makes its way down through a narrow gorge. Its entire length is about two miles, yet it falls a full 1,000 feet from its source to its mouth. The "cascade" is an abrupt fall of about 40 feet. (Photograph by Robert Campanile.)

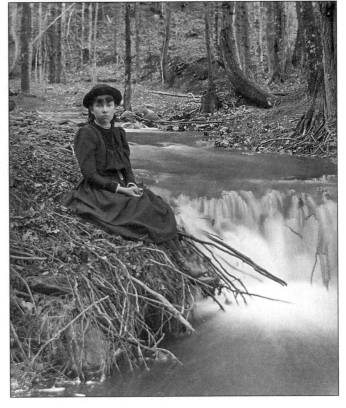

BEL BY THE CASCADES. This charming turn-of-the-century photograph shows a young girl named Bel sitting by the falls. The cascades have been known to generations of North Adams citizens as a retreat in summertime. In Nathaniel Hawthorne's notes on North Adams, he refers to it as the "Singing Brook."

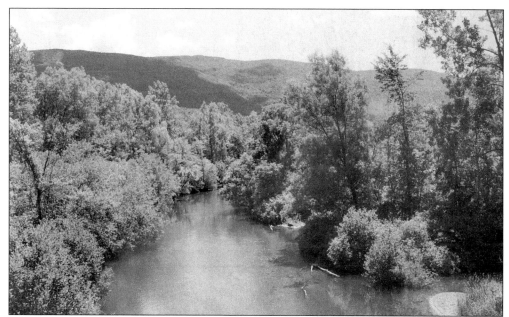

THE HOOSIC RIVER *AU NATURALE*. The north branch of the Hoosic River rises in Stamford, Vermont. The south branch begins in Cheshire Lakes. Both branches join in North Adams near the Brown Street bridge. The river flows northwest, which is unusual in New England. It was a major factor in the development of early industry, when waterpower was essential. (Photograph by Robert Campanile.)

THE HOOSIC RIVER UNDER CONTROL. The Hoosic River flooded its banks often, causing some devastating floods and spreading water-borne disease. Some floods washed away every house on Main Street. After destructive floods in the 1920s, 1930s, and 1940s, the city decided to build the control chutes shown here. Today it is a major preserve for local and migrating wildlife. (Photograph by Robert Campanile.)

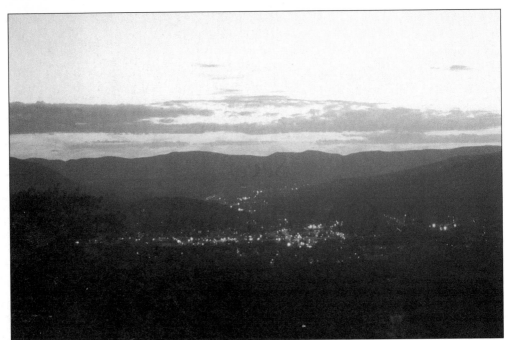

SUNSET ON THE WESTERN SUMMIT. In 1838, Nathaniel Hawthorne wrote, "The village viewed from the top of a hill to the westward, at sunset, has a peculiarly happy and peaceful look; it lies on a level, surrounded by hills, and seems as if it lay in the hollow of a large hand." (Photograph by Robert Campanile.)

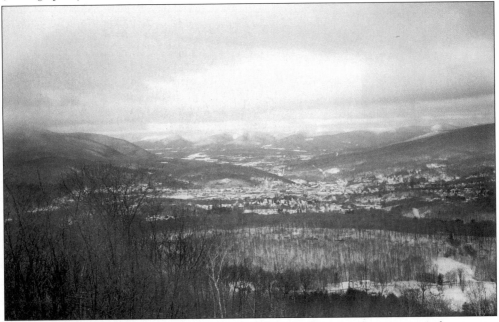

NORTH ADAMS, JANUARY 1, 2001. A new millennium dawns as the new year's first sunrise over North Adams is captured in this city portrait from the western summit of the Hoosac Mountains. Ever optimistic, the city and its people look to a future filled with great expectations and calm dignity. (Photograph by Robert Campanile.)